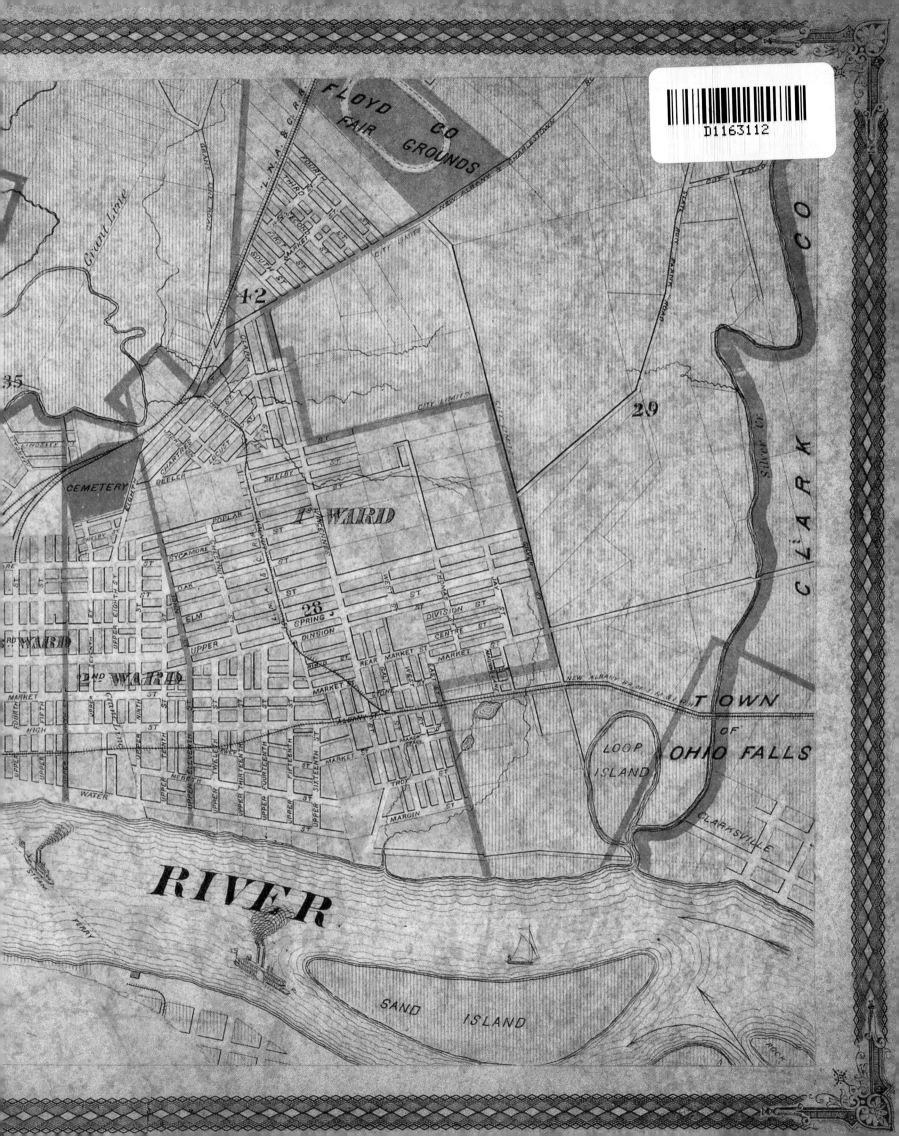

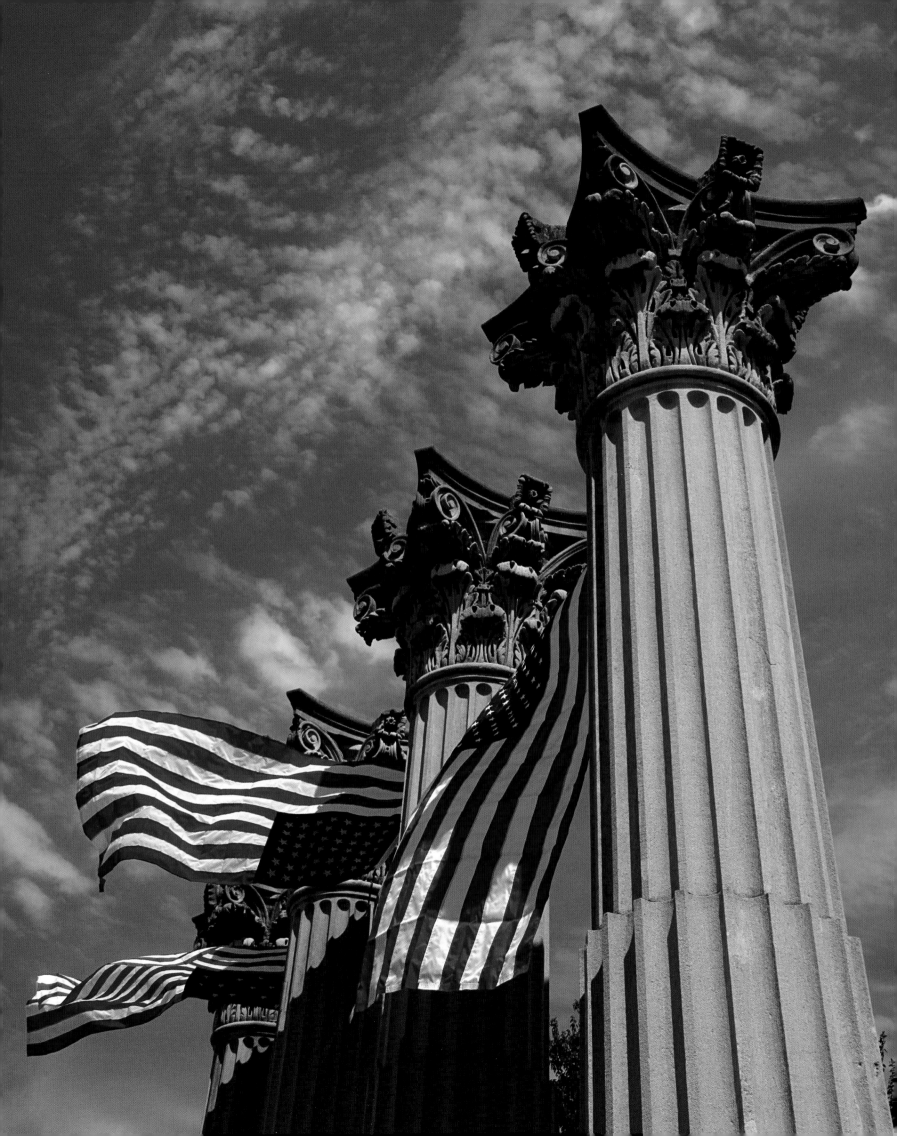

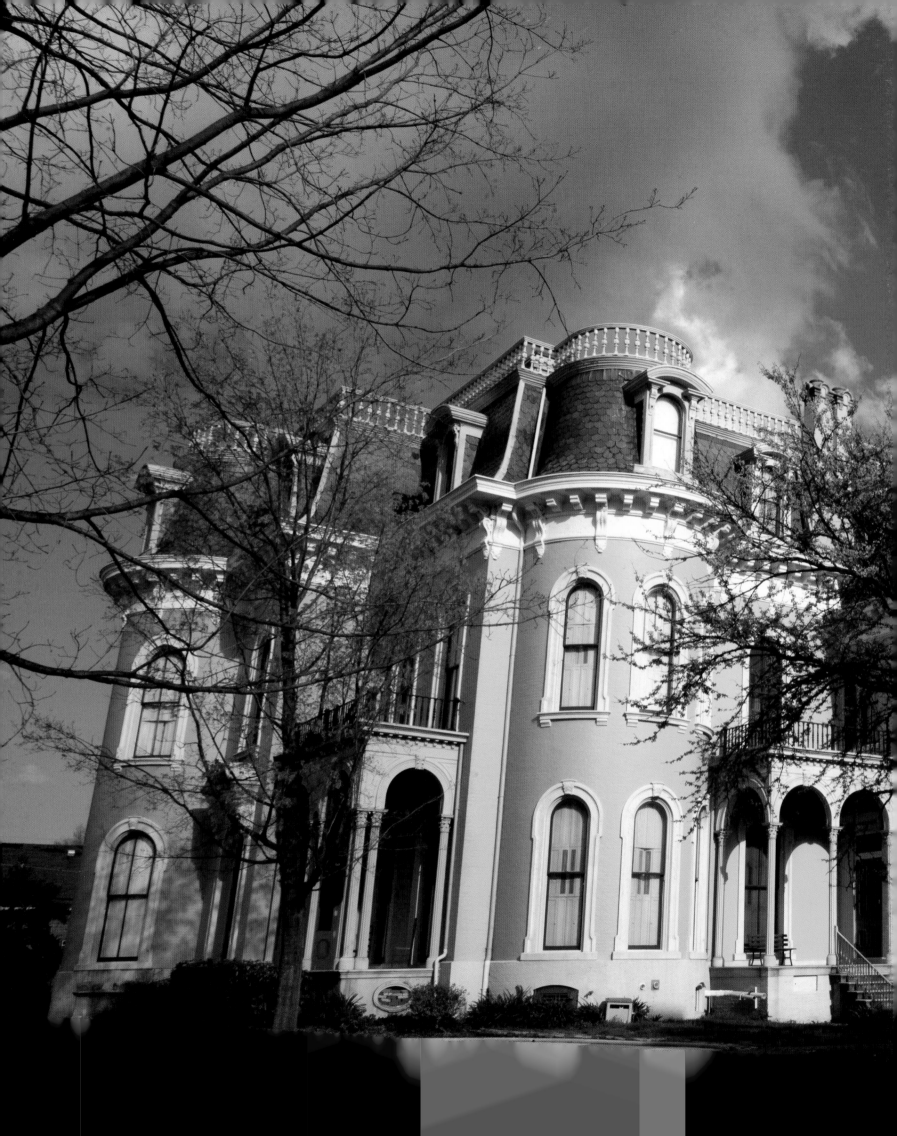

HISTORIC NEW ALBANY
INDIANA
BY THE RIVER'S EDGE

History text by
James A. Crutchfield

Caption text by
David Barksdale
President, Floyd County Historical Society

Photography by
Pulitzer Prize-winning photographer
Robin Hood

GRANDIN HOOD
Publishers

Historic NEW ALBANY, Indiana: By the River's Edge

The publisher acknowledges and wishes to thank the following
individuals and organizations for their support in providing invaluable
archival photographs and artifacts from their collections:

David Barksdale for numerous postcards and artifacts from his
private collection included in this book.

Carnegie Center for Art & History

The Scribner House Museum

Culbertson Mansion State Historic Site

Floyd County Historical Society, Padgett Museum

New Albany-Floyd County Public Library, Stuart Barth Wrege Indiana
History Room

Falls of the Ohio State Park Interpretive Center

Annette L. Clark Art Gallery, New Albany-Floyd County Public Library
Portraits, page 37

Gary Lucy Gallery, Washington, Missouri, www.garylucy.com
Original painting "The *New Orleans* Steaming Upstream by
Moonlight, 1811" pages 28–29

Bank of America, St. Louis, Missouri
Original painting, "Race Between the *Natchez* and the *Robt. E. Lee*,"
Dean Cornwell, page 51

Bob Ostrander, HOOSIER BEER, www.indianabeer.com
Original labels and advertisements of New Albany breweries,
pages 38–39

Mike Ricke
Photographs, pages 130–131, 136

Digital processing by Lauren Hood

Book design by Robertson Design
Franklin, Tennessee

New Albany Bicentennial Commission
P.O. Box 587
New Albany, IN 47150
www.newalbany200.org
E-mail: newalbany200@gmail.com
Facebook/Twitter: http://www.facebook.com/newalbany200

Published by:
Grandin Hood Publishers
1101 West Main Street
Franklin, Tennessee 37064

Printed in Canada by Friesens America

ISBN: 978-0-9771281-0-5

Ohio River and the Sherman Minton Bridge at dusk

Page 1: American flags of 1813, 1913, and 2013 displayed on
columns from the historic Floyd County Courthouse as a tribute to
New Albany's Bicentennial.

Previous spread: Culbertson Mansion (1867–69), East Main Street.
The Second Empire mansion was constructed for New Albany
entrepreneur, banker, and philanthropist William S. Culbertson.

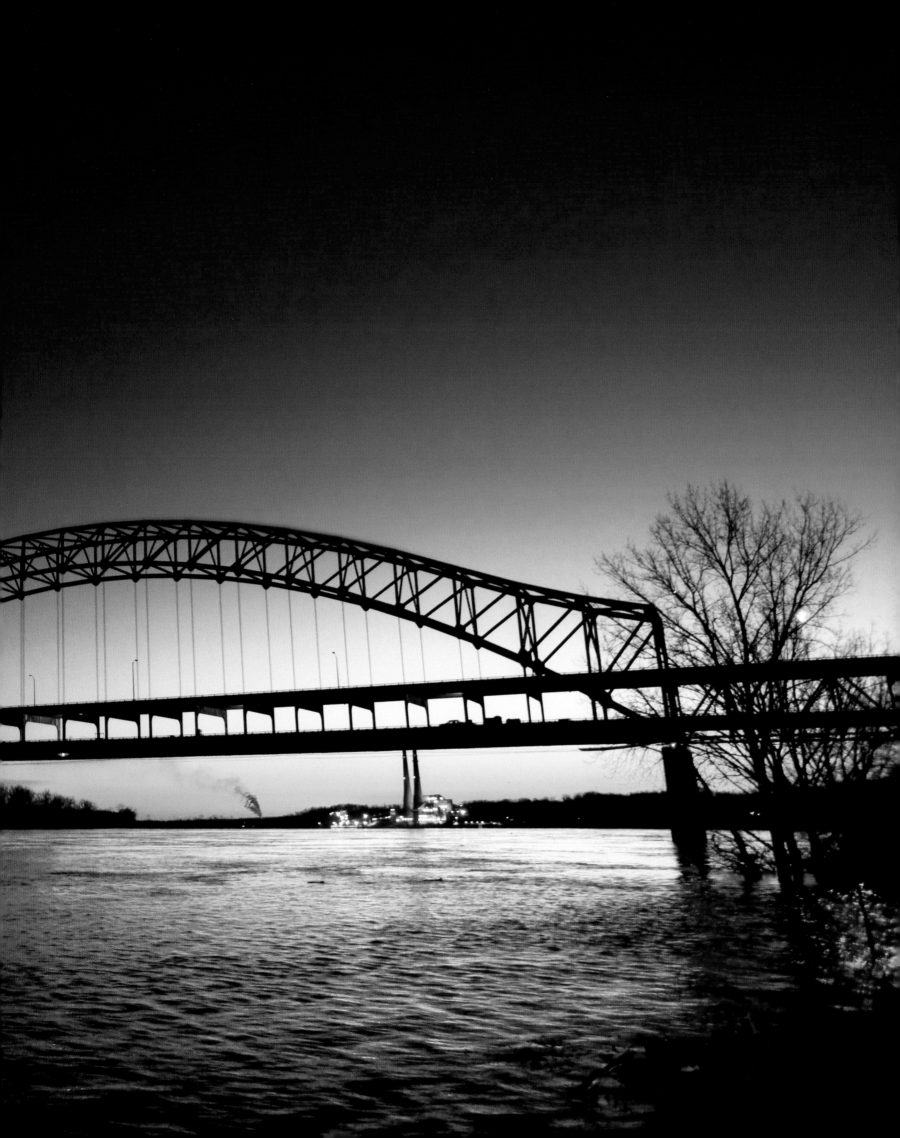

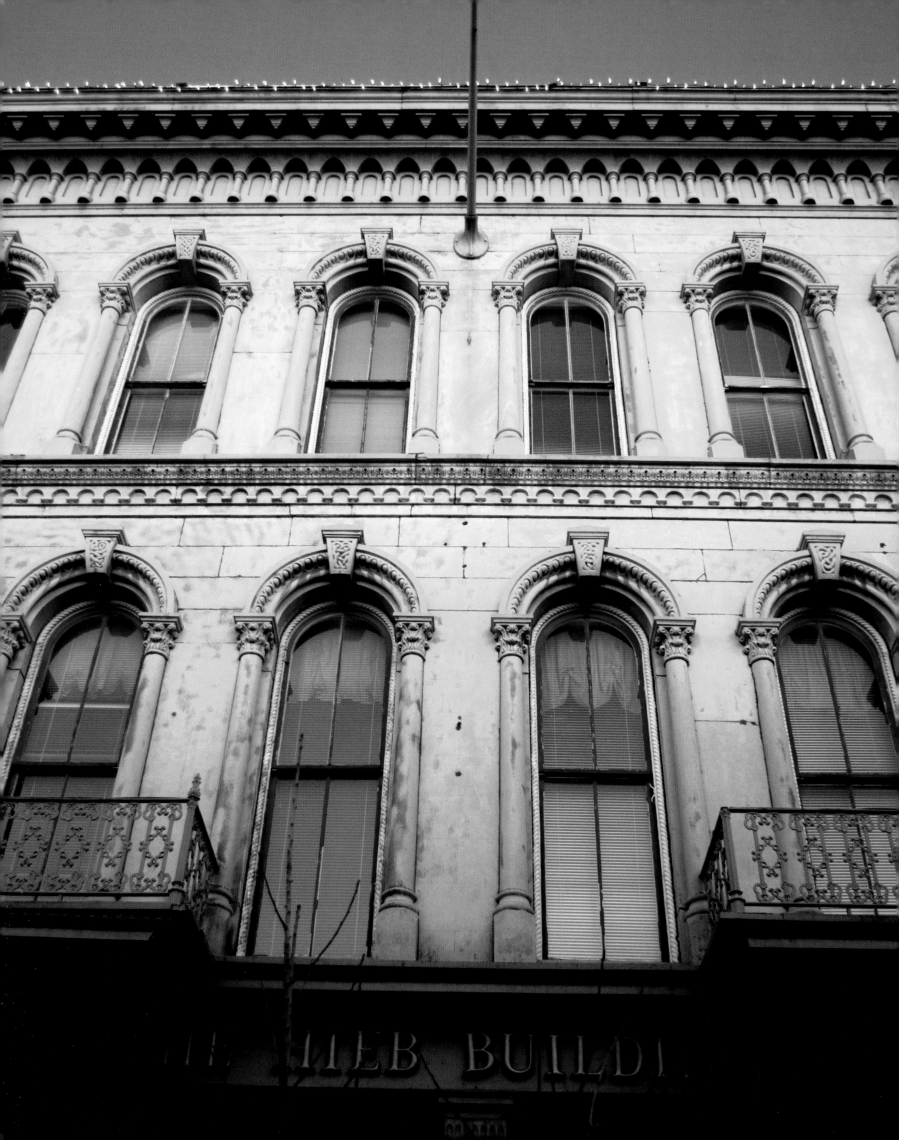

Acknowledgments

The publisher wishes to thank the individuals who graciously contributed time and effort to make this book possible. In particular, the greatest measure of gratitude is extended to former mayor Douglas B. England, who in 2009 established the New Albany Bicentennial Commission, and to current mayor Jeff Gahan and the City of New Albany for their continuing support of the Commission and its programs celebrating the 200th anniversary of New Albany's founding, including production of this commemorative book.

Grateful appreciation also goes to Bicentennial Commission book committee members: Bob Caesar, Chair; David Barksdale; Vic Megenity; and Barbara Zoller for their able and energetic support of Grandin Hood's process of orientation, research, archival collection, and editing of the information and materials included in this book. Their enthusiasm and cautious guidance were inspiring and ensured the success of the project.

Particular recognition is given to Betty C. Menges and Nancy Strickland, librarians at the Stuart B. Wrege Indiana History Room, New Albany-Floyd County Public Library, and to Alice Glover, Floyd County Historical Society, for their diligent efforts to provide information and archival photographs significant to New Albany's history.

Special appreciation is extended to the "Stories Behind the Stones" volunteer re-enactors of the Bicentennial Living History Committee and their coordinator, Barbara Zoller, for recreating significant New Albany historical events, such as the "William Culbertson Funeral" at Fairview Cemetery, "Pioneers Moving West on the Buffalo Trace," and "Christmas at the Scribner House." Also, a personal thanks to David J. Ruckman, L.S. of Draw Survey & Map, LLC, for providing invaluable information and assistance pertaining to the various routes of the historic Buffalo Trace through Floyd County. Thank you also to Pam Peters and James Thornton Eiler for their knowledgeable research for the entries about Lucy Higgs Nichols, Col. Paul Jones, and the *Lucy Walker* steamboat explosion. A salute to Mickey Thompson, New Albany street commissioner, for special assistance in hanging seasonal decorations from the iconic columns of the former Floyd County Historic Courthouse.

Finally, a special tribute is extended to the members of the New Albany Bicentennial Commission members for their vision and continuing enthusiasm for publication of this book.

LEFT: HIEB BUILDING, BUILT 1870, 316-318 PEARL STREET. THE FIRST AMERICAN-MADE, GROUND AND POLISHED PLATE GLASS, SUPPLIED BY CAPT. JOHN B. FORD, KNOWN AS THE FATHER OF PLATE GLASS IN AMERICA, WAS HUNG IN THE BUILDING'S STOREFRONT.

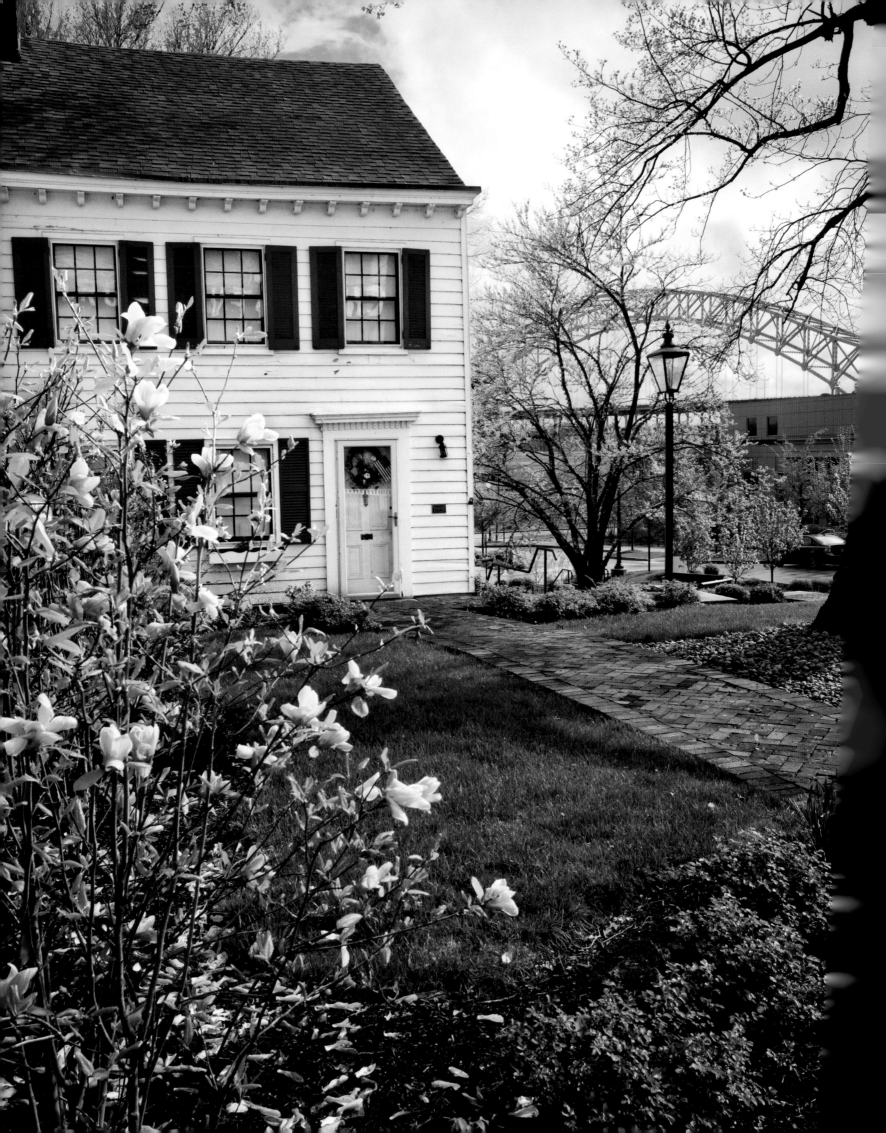

Bicentennial Commission Members

Shelle England	Co-chairperson
Bob Caesar	Co-chairperson
Barbara Zoller	Vice Chairperson
Vic Megenity	Treasurer
John Coffman	Commission Member
David Barksdale	Resident Historian
Jim Meeks	Co-chair Events Committee
Pat Harrison	Co-chair Events Committee
Yvonne Grundy	Commission Member

Committee Members

Sally Newkirk	Arts Committee Chairperson
Doris Leistner	First Families Project
Jerry Wayne	Public Relations/Communications
Oneida Philips	Diversity Committee
Rosalie Dowell	Book Launch Event Chairperson
Julie Schweitzer	Arts Council Committee
Vern Eswine	Electronic Media
Patty Fischer	Harvest Homecoming Liaison
Connie Sipes	NAFC School System Committee
Susie Gahan	NAFC School System Committee
Becky King	NAFC School System Committee
Kathy Kessinger	Scribner House
Jim Munford	Silver Grove Neighborhood
Mary Munford	Secretary
Matthew Vanover	Committee Member
Letty Walter	Old-Fashioned Games Committee
Don Harshey	Veterans Committee

LEFT: SCRIBNER HOUSE, BUILT 1814, STATE AND MAIN STREETS. THIS FEDERAL-STYLE CLAPBOARD HOME BUILT FOR ONE OF NEW ALBANY'S FOUNDERS, JOEL SCRIBNER, IS THE OLDEST HOUSE IN THE CITY.

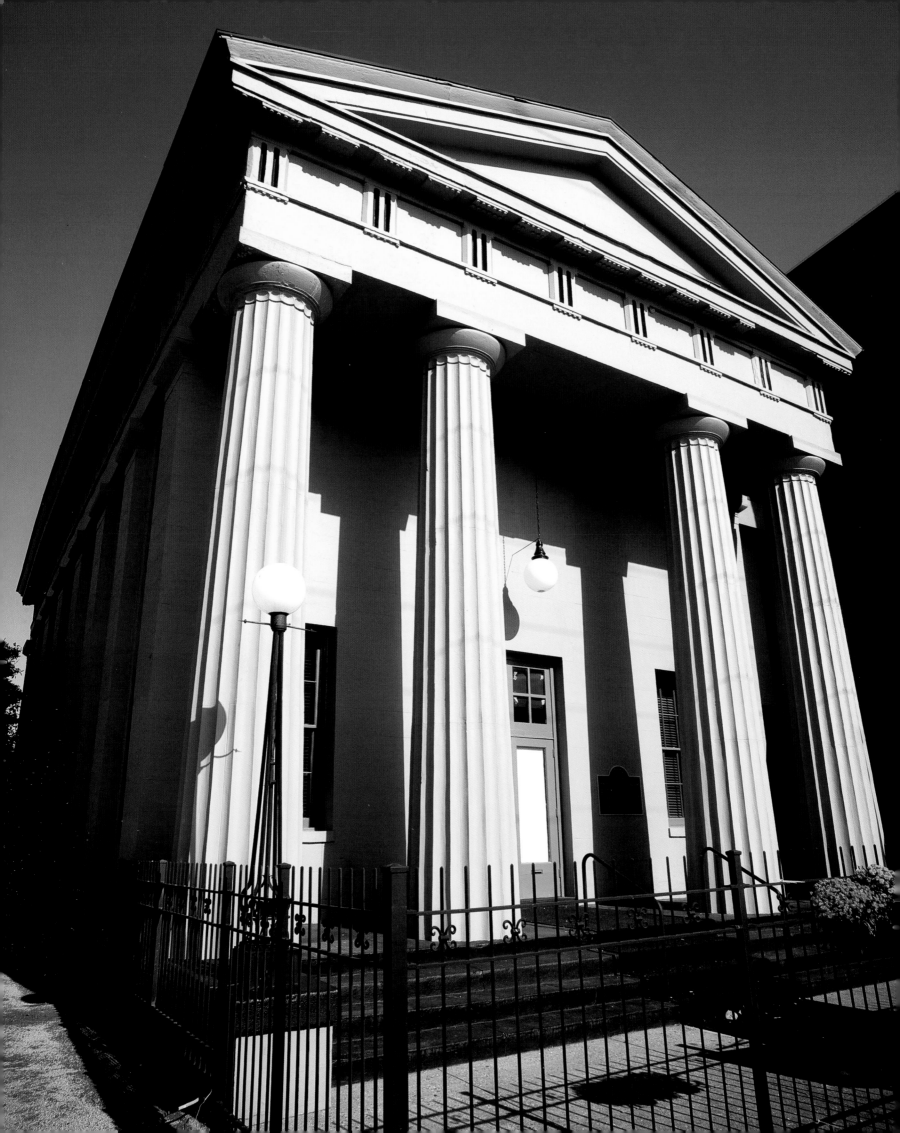

FOREWORD

It is a distinct pleasure and honor to be involved with the publication of *Historic New Albany, Indiana: By the River's Edge*. The words and photographs in this book offer a dynamic portrait of a community long recognized for its history as a center of business enterprise and genteel lifestyle. Since its founding, New Albany, strategically ensconced on a gentle bend of the Ohio River and just below the ancient Falls of the Ohio, has attracted business entrepreneurs, merchants, industrialists, craftsmen, and visionaries to the charming environs of the town. The dreams and hard work of these men and women throughout two hundred years have created an indelible image for New Albany as a center of prosperity and American enterprise.

New Albany's industrial innovations and success over two centuries, together with its significant role in many colorful chapters of American history, has engendered pride among its citizens for that heritage. From this has grown an immense spirit of gracious living, neighborly attitudes, and family values.

This community spirit attracted my wife, Penny, and me to New Albany nearly thirty years ago, where we decided to make our home and raise our three children, Jon Ryan, Katie, and Max. Having business offices in several states, we could live almost anywhere. But it is here in New Albany where we became enmeshed in the gracious fabric of the community, and where our growing

family's aspirations were fulfilled. My family and I are proud to call Southern Indiana home and to be a part of New Albany's greatness at a time when the city is experiencing an exciting renaissance of growth and prosperity.

This book will become an enduring icon of the New Albany Bicentennial Celebration. It is a clarion call for us all to recognize the importance of preserving the city's historic character and tradition as we look ahead to a third century of progress. The Neace family is proud to support the New Albany Bicentennial Committee in their efforts to bring this book to the public.

—John Neace

Left: Indiana State Bank Building, located at 203 East Main Street, was constructed in the Greek revival style of architecture in 1837 as one of ten original branches of the Indiana State Bank.

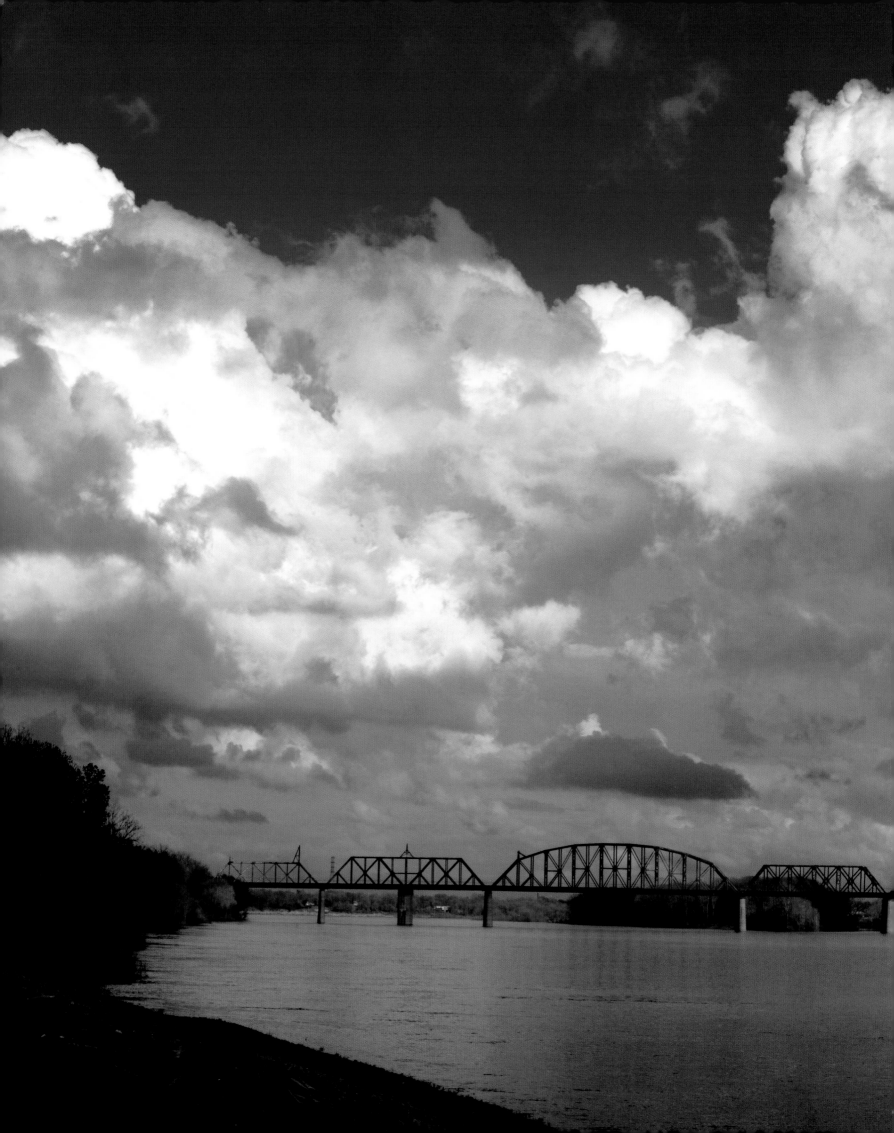

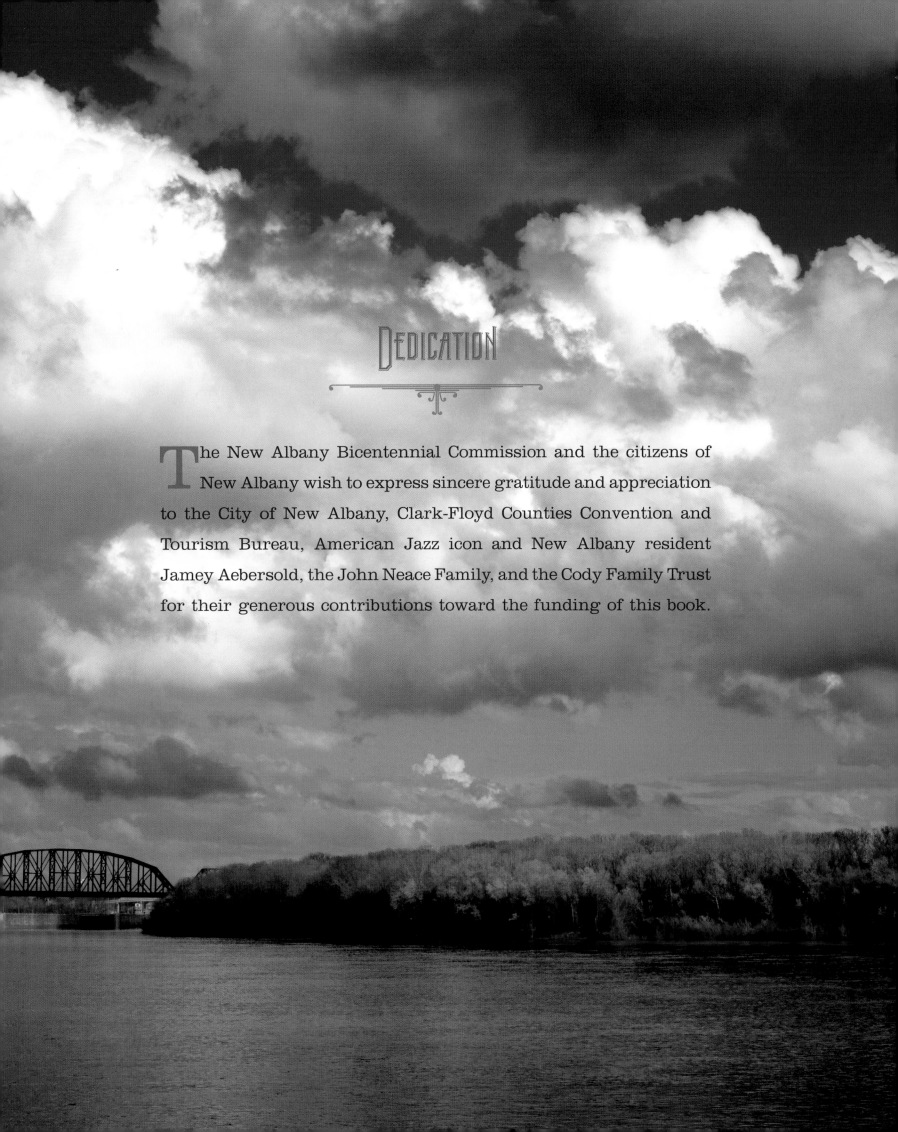

DEDICATION

The New Albany Bicentennial Commission and the citizens of New Albany wish to express sincere gratitude and appreciation to the City of New Albany, Clark-Floyd Counties Convention and Tourism Bureau, American Jazz icon and New Albany resident Jamey Aebersold, the John Neace Family, and the Cody Family Trust for their generous contributions toward the funding of this book.

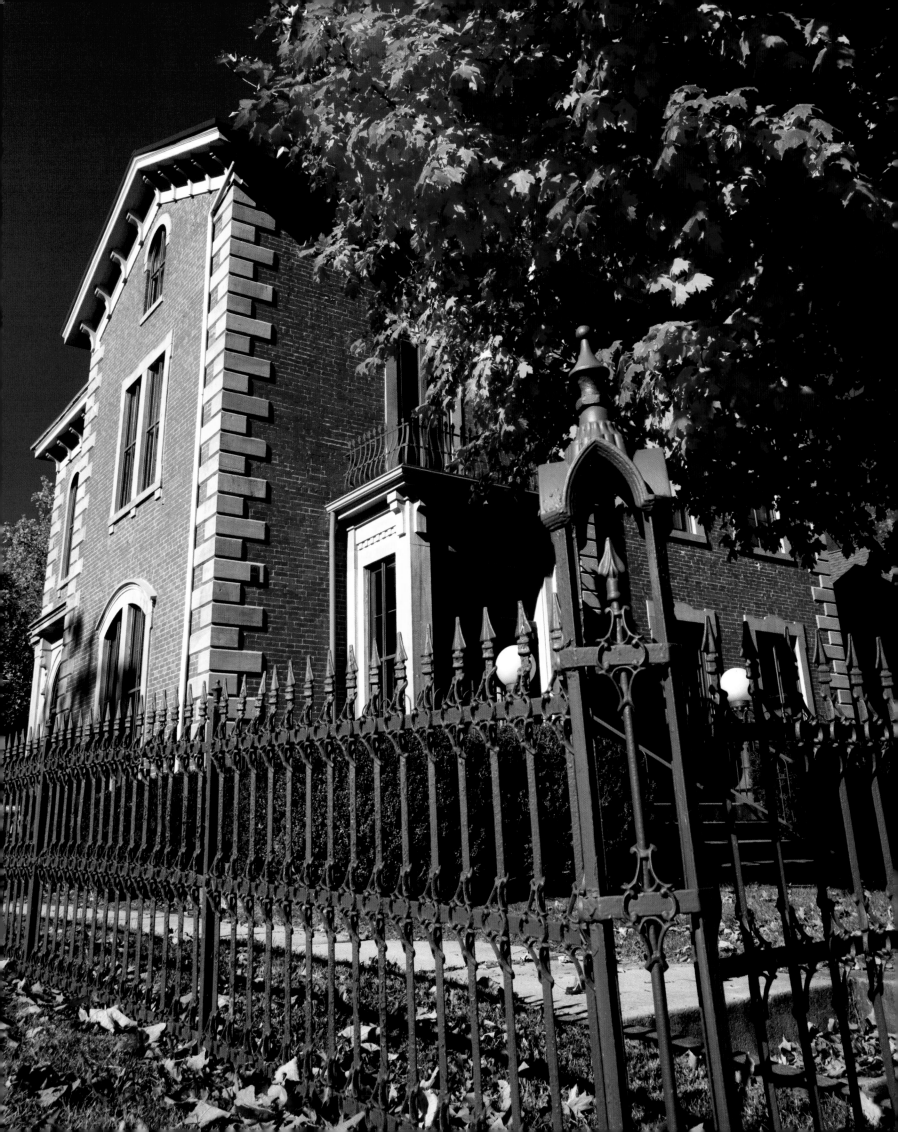

Preface

"Welcome Home"— Whether you're a current resident, former resident, or planning to relocate here, this book is for you. The New Albany Bicentennial Commission was seeking a method to bring the history of New Albany to life in a special way. After long deliberation and conferring with numerous community leaders, the decision was made to produce this commemorative edition celebrating the colorful history and continuing story of our fine city. The book is also intended as a source of capital for funding yearlong events for all our citizens to enjoy during the 200th anniversary.

The Bicentennial Commission expresses gratitude to the many donors and sponsors who have contributed funding, energy, and support necessary to make this book a success. We applaud Grandin Hood Publishers for the innumerable days their creative team spent in New Albany and the devoted enthusiasm they exhibited in telling our story in a meaningful and memorable publication.

Years after the bunting is down, the fireworks displays have ended, and the bands have quieted their patriotic tunes, this book will serve as a treasured icon of New Albany's historic past and bright future.

—Robert C. Caesar, Co-chairman
New Albany Bicentennial Commission

Left: The Brooks-Bradley House, located at 815 East Market Street, was constructed for James Brooks, Esq. around 1855 in the Italianate style of architecture. Mr. Brooks was the founder and first president of the New Albany-Salem Railroad, later known as the Monon, *The Hoosier Line*.

Previous spread: Ohio River and the historic Kentucky & Indiana Railroad Bridge from the Ohio River Greenway at New Albany's public boat ramp on Water Street

HISTORIC
New Albany
INDIANA

BY THE RIVER'S EDGE

A PLAN of the RAPIDS, in the River Ohio, by Thos. Hutchins.

From A to B. is the Carrying Place on the Northern Side of the Okio.
From C to D. is the safest and shortest Carrying Place.
The dotted Line represents the Channel of the River.

THIS 1766 MAP OF THE FALLS OF THE OHIO WAS DRAWN BY THOMAS HUTCHINS, A BRITISH ENGINEER. AS A MEMBER OF CAPTAIN HARRY GORDON'S EXPLORATION PARTY, HUTCHINS SURVEYED AND EXPLORED THE OHIO RIVER AND SPENT FOUR DAYS DOCUMENTING THE OHIO FALLS RAPIDS.

TIME LINE

| 1780 | 1781 | 1782 | 1783 | 1784 |

1780s
The Buffalo Trace, an extension of the Wilderness Road, provides an accessible avenue for thousands of pioneers from the Eastern settlements seeking new lands in the West.

1781
The State of Virginia approves a 150,000-acre land grant for General George Rogers Clark and his officers and men for their Revolutionary War services.

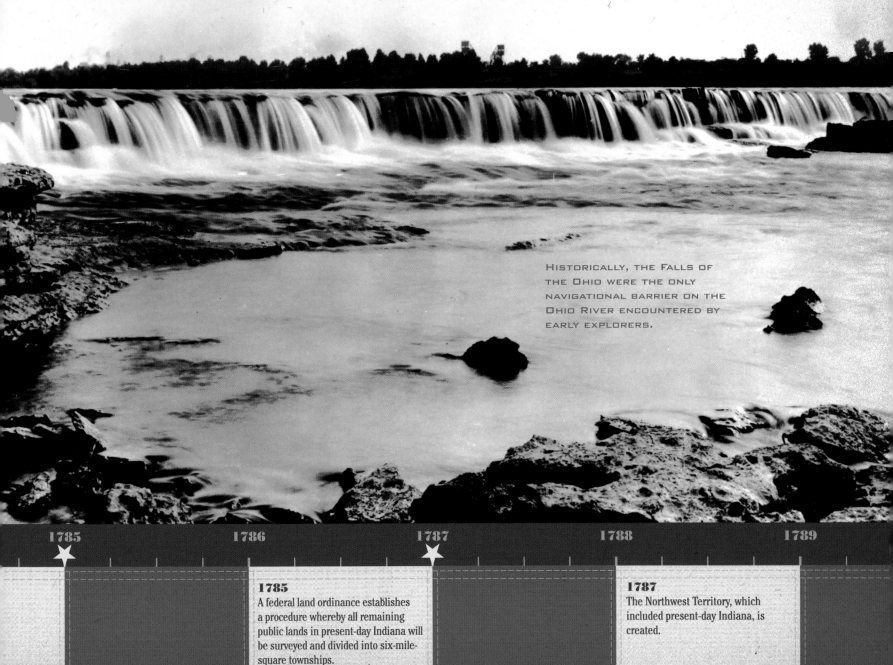

As the crow flies, the distance between New York City and Cincinnati is about seven hundred miles. In the early nineteenth century, however, if one left New York and traveled westward across New Jersey and Pennsylvania to Pittsburgh, then floated down the Ohio River, the journey would have been considerably longer, through forest and prairie, and along river and stream. But in mid-October 1811, such an excursion was exactly what Joel Scribner had in mind when he announced that he was closing his mercantile business in New York and moving with his

HISTORICALLY, THE FALLS OF THE OHIO WERE THE ONLY NAVIGATIONAL BARRIER ON THE OHIO RIVER ENCOUNTERED BY EARLY EXPLORERS.

1785 1786 1787 1788 1789

1785
A federal land ordinance establishes a procedure whereby all remaining public lands in present-day Indiana will be surveyed and divided into six-mile-square townships.

1787
The Northwest Territory, which included present-day Indiana, is created.

wife, Mary, and the couple's seven children to Cincinnati, where they would start their lives afresh amidst America's new western frontier. About one year later, Joel's two siblings, Nathaniel and Abner, joined him in Cincinnati. Within a few weeks, the three brothers were on the move again, this time floating even farther downstream to land below the Falls of the Ohio, across the river from Portland. When they arrived in early March 1813, neither the long distance traveled nor the incredible hardships encountered during the difficult trek had dampened their spirits or obstructed their resolve to make this remote Eden their home. At that spot, on the northern bank of the Ohio River west of Silver Creek, they established a new town which they called New Albany, in honor of the capital of their home state of New York.

BEFORE THE AMERICAN OCCUPATION BY GENERAL GEORGE ROGERS CLARK (UPPER LEFT) OF WHAT BECAME THE NORTHWEST TERRITORY, THE REGION WAS INHABITED BY SEVERAL TRIBES OF INDIANS (LOWER LEFT). CLARK'S ORIGINAL LAND GRANT FROM VIRGINIA (LOWER RIGHT) GAVE HIM POSSESSION OF WHAT BECAME KNOWN AS CLARK'S GRANT (UPPER RIGHT).

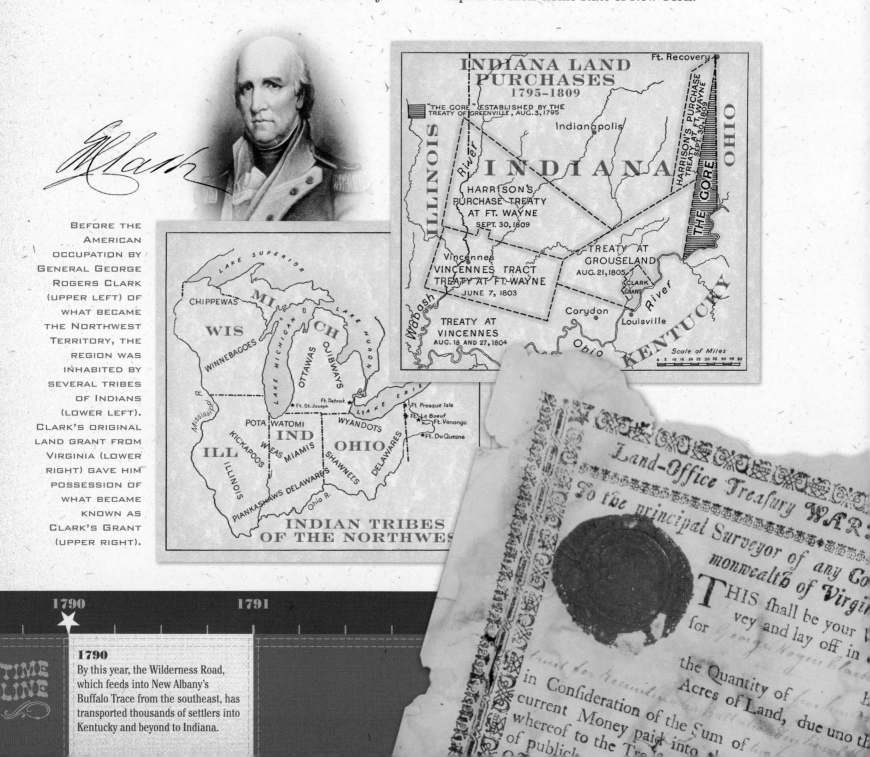

TIME LINE

1790

1791

1790
By this year, the Wilderness Road, which feeds into New Albany's Buffalo Trace from the southeast, has transported thousands of settlers into Kentucky and beyond to Indiana.

Nearly three decades before the Scribners arrived at their destination, Thomas Jefferson, the forty-one-year-old Virginia delegate to the Continental Congress, had proposed the creation of a federally administered territory that would encompass most of the new nation's lands lying between the Ohio and Mississippi Rivers. According to Jefferson's elaborate plans, as the region's population grew, it would eventually be divided into nine new states, bearing such grandiose names as Cherronesus, Illinoia, Polypotamia, and Michigania, among others.

Jefferson's bold idea was superseded in 1787, when the federal government created the Northwest Territory, from which at least three, but not more than five, future states, among them Indiana, were authorized to be formed. Fortunately for today's residents of all five states that eventually grew out of the territory—Ohio, Indiana, Illinois, Michigan, and Wisconsin—Congressman Jefferson's proposed fanciful names were dropped from the legislation. In 1800, the Northwest Territory was split into two parts and its western section became Indiana Territory. Future president of the United States William Henry Harrison (1773–1841) was appointed the first territorial governor, and the capital was established at Vincennes.

During the American Revolution, when Harrison was still a mere child growing up in coastal Virginia, one of his upcountry neighbors, Virginia militia lieutenant colonel (later general) George Rogers Clark (1752–1818), was in pursuit of the British in the soon-to-become Northwest Territory. For their efforts in expelling the British from what was then called the Illinois Country, Clark and his men were awarded 150,000 acres of prime land, called Clark's Grant and located north of the Ohio River in present-day southeastern Indiana. Clark ended up with a little more than 8,000 acres for himself, 1,500 acres of which were located in present-day New Albany. He eventually built a two-room log house on his property east of Silver Creek which he called Clark's Point.

1796　　　1797　　　1798　　　1799

1794
General "Mad" Anthony Wayne's victory over Indians at Fallen Timbers in present-day Ohio secures the Northwest Territory for American settlement.

1796
English traveler Francis Baily documents the Falls of the Ohio in his journal which is posthumously published in 1856.

Lewis and Clark Expedition

At Clark's Point, in July 1803, one of George Rogers Clark's younger brothers, William Clark, received a letter from his old army acquaintance, Meriwether Lewis, who by that time was the personal secretary of President Thomas Jefferson. The letter explained that Jefferson had determined to send a government-sponsored exploring party up the Missouri River and across the Rocky Mountains, all the way to the Pacific Ocean. Lewis had been named the mission's leader and he had a simple request: he wanted William Clark to "participate with me in its fatiegues, its dangers and its honors," adding that "believe me there is no man on earth with whom I should feel equal pleasure in sharing them as with yourself."

On October 26, 1803, describing in simple language the genesis of what would become a defining moment in America's westward expansion,

William Clark wrote in his journal, "Rain at Louisville [and] at Clarksville. Capt. Lewis and Capt. Wm. Clark set out on a Western tour." Three years later, the men of the Lewis and Clark Expedition returned, following an arduous and grueling trip to the mouth of the Columbia River and back again. They had traveled nearly eight thousand miles and along the way had documented fifty Indian tribes, 178 new plant species, and 122 new animal species.

Following the momentous expedition, Lewis tragically lost his life along the Natchez Trace in Tennessee in 1809 — either by suicide or murder, depending on which theory one embraces. William Clark went on to become governor of Missouri Territory and, later, United States Superintendent of Indian Affairs with headquarters in St. Louis. He died in 1838 and his funeral drew the largest crowd ever recorded in the city to date.

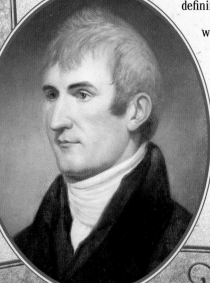

MERIWETHER LEWIS (1774–1809) (LEFT) AND WILLIAM CLARK (1770–1838) (RIGHT). THE PAINTING ABOVE, BY MICHAEL HAYNES, DEPICTS LEWIS AND CLARK DEPARTING CLARK'S POINT ON OCTOBER 26, 1803.

By the time the Scribner brothers arrived at the site that would become New Albany in 1813, the Ohio River had for many years been a primary thoroughfare to the West for explorers, adventurers, settlers, and the military. From its source at the junction of the Allegheny and Monongahela Rivers at Pittsburgh, the nearly-one-thousand-mile-long river was obstructed by only one natural barrier: the Falls. When first observed by Anglo explorers, this natural wonder consisted of a series of cataracts that dropped twenty-six feet over a stretch of about two-and-one-half miles. Francis Baily, an Englishman who traveled in the eastern United States in the late eighteenth century, described the obstacle and its environs. "The Ohio here is near a mile wide, and… what tends to signalize this place, and to render its prospect still more enchanting as well as awfully grand, is the almost perpetual presence of an immense cataract of water, formed by the Ohio hurrying itself with the greatest rapidity over a ledge of limestone rocks, which extend from one side of the river to the other."

The underlying rock strata at the Falls date back hundreds of millions of years to the early periods of geologic history when the beds were laid at the bottom of extensive oceans covering this part of the present-day United States. Predating the dinosaurs by a couple of hundred million years, the fossil remains which are visible today represent very early examples of crinoids, snails, trilobites, corals, brachiopods, and other simple, invertebrate animal life, as well as primitive plant specimens.

Within a thousand or so years of the arrival

1800 1801 1802 1803 1804

1800
Indiana Territory is created. William Henry Harrison is appointed first territorial governor.

1803
Meriwether Lewis and William Clark depart the Falls of the Ohio for the first leg of their monumental journey to the Pacific Ocean and back again.

of Indians in the New World, wandering bands of natives had made their way south to the present-day Ohio River. Archaeologists have identified several prehistoric groups, the most advanced being the Mississippian culture, which was noted for its highly evolved agricultural economy and its towering temple mounds. Mississippian peoples were already in decline when the first Europeans explored the region, replaced by hunting bands of such wandering historic tribes as the Mosopelia, Delaware, Miami, and Shawnee.

In ancient times the Buffalo Trace, a westward extension of the trail that became known as the Wilderness Road, crossed the Ohio River at the Falls near the mouth of Silver Creek and provided herds of bison, as well as Indian hunters, with a thoroughfare into present-day Indiana and points north and west.

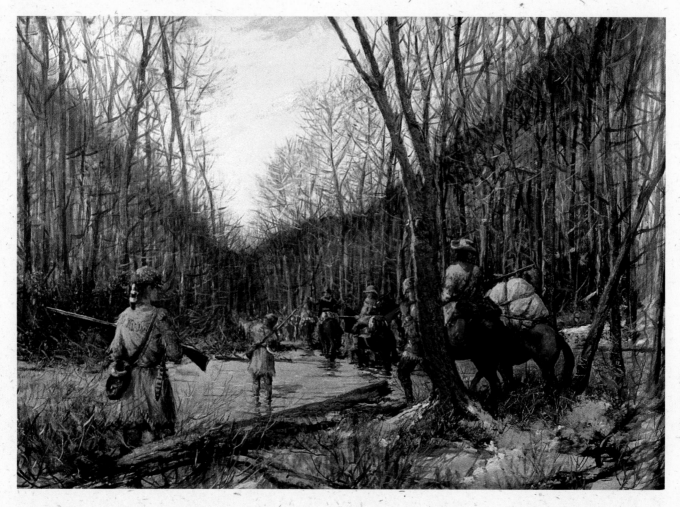

THE TERMINATION OF THE FRENCH AND INDIAN WAR OPENED THE FLOODGATES TO A MASSIVE MIGRATION OF THOUSANDS OF PIONEERS AND THEIR FAMILIES INTO THE AREA LATER KNOWN AS THE NORTHWEST TERRITORY.

1805 1806 1807 1808 1809

TIME LINE

1805
The Indiana Canal Company is chartered by the territorial legislature to build a canal around the Falls of the Ohio River.

1809
Illinois Territory is established from land previously a part of Indiana Territory.

John James Audubon, celebrated as one of America's best-known wildlife artists, developed his initial skills studying and painting birds at the Falls of the Ohio and the area along Silver Creek that is now New Albany. Local legend suggests that Audubon also often visited the Silver Hills region to paint.

Audubon was born in 1785 in Santo Domingo in the present-day Dominican Republic. As a youngster, he moved to France with his father, then migrated to the United States in 1803 and became a naturalized citizen nine years later. He settled in

Pennsylvania to oversee some of his father's property. Eventually, he married, went into the mercantile business, and moved to Louisville, Kentucky, where he opened a store with a partner, Ferdinand Rozier.

In Louisville, Audubon's interest in business quickly diminished, and his love of nature painting regularly drove him to the Ohio River, where he spent days upon days painting and transcribing notes about the many birds that either nested or wintered there. Among the species he encountered were the snowy owl and the common merganser, both in mid-December 1809. Images of these two species, along with twelve others studied nearby, appear in his widely published masterpiece *Birds of America*.

Birds of America, published between 1828 and 1839, consists of 435 individual engravings, each measuring nearly twenty-seven by forty inches. The artist, who personally marketed his opus, sold around two hundred sets at $1,000 each, an enormous sum of money during the mid-nineteenth century. Today, the price for a complete, pristine set of *Birds*—when one can be found—might easily fetch in excess of two million dollars.

White settlers later adopted the Trace and used the northern section as a pathway to Vincennes and its westward extension as the gateway to the Mississippi River Valley and beyond.

Locally, the Buffalo Trace split into a myriad of trails that meandered among Silver Hills and the many streams and creeks that crisscrossed the region. Several streets and roads in present-day New Albany and Floyd County are direct outgrowths of these many trails, including Bald Knob Road, Klerner Lane, Old Ford Road, Old Vincennes Road, and Slate Run Road. One of the more prominent trails ran from Gutford/Charlestown Road to Hilltop Limerick Village, where it split, one branch proceeding southwestward and crossing Eighth Street at the old Monon Spur near the Padgett Complex and then to downtown. The other branch left Hilltop and followed Eighth Street to Daisy Lane, thence up the knobs through Grandview, to join Old Vincennes Road.

For the Scribners, the neighborhood below the Falls of the Ohio, west of both Silver Creek and Clark's Grant, proved to be a perfect spot upon which to settle and organize a new village. The location of the Falls upriver from the town site would allow for the development of downstream traffic with the lucrative markets of Natchez and New Orleans, with no natural obstacles to be encountered along the way. Land was also relatively easy to acquire. By the time the Scribners arrived in the region, Territorial governor William Henry Harrison, through a series of treaties with various Indian tribes across the region, had already extinguished Indian title to tens of thousands of acres of southern Indiana Territory lying along the north bank of the Ohio River. Upon treaty ratification, this vast region was opened to hundreds of land-hungry settlers who, like the Scribners, were moving from the East.

The Scribner brothers soon began negotiations with Colonel John Paul to purchase some 860 acres for $8,000. Upon that property, located directly west of Clark's Grant (present-day Grant Line Road delineates the western boundary of the Grant), the new village of New Albany was started. Joel Scribner built a large double-pen log house for his family, located at

PRIOR TO HIS BECOMING PRESIDENT, WILLIAM HENRY HARRISON WAS INSTRUMENTAL IN SECURING LARGE TRACTS OF THE SOUTHERN INDIANA TERRITORY FROM NATIVE AMERICAN TRIBES.

W. H. Harrison

TIME LINE

1810 1811 1812 1813 1814

1811–1812
Nicholas Roosevelt, aboard the *New Orleans*, proves that steamboat travel is practicable upon America's inland waterways.

1813
The Scribner brothers of New York State—Joel, Nathaniel, and Abner—arrive at the future site of New Albany. The new town is laid out and building lots are sold.

the corner of present-day East Sixth and Main Streets. A surveyor named John K. Graham was hired to lay out the town, which consisted of a number of streets running north and south from East Fifth to West Fifth Streets and east and west from Water to Oak Streets. By mid-August, the Scribners had advertised in many Eastern newspapers the creation of the new town and the availability of lots therein for purchase. One such notice appeared in the July 8 issue of the *Philadelphia Aurora* and proclaimed the desirability and commercial attractiveness of the New Albany environs.

The advantages New Albany has in point of trade, are perhaps unrivalled by any on the Ohio, as it is immediately below all the dangers which boats and ships are subject to in passing over the Falls.... From the vast quantity of excellent ship timber, the great abundance of iron ore, within a few miles, and the facility with which hemp is raised, it is presumed that this will be one of the best ports in the United States for the building of vessels, as well as the loading [of] them.

By the time the first public sale of New Albany lots occurred on November 2 and 3, 1813, several settlers had already built log houses.

THIS ADVERTISEMENT FROM THE *PHILADELPHIA AURORA* NEWSPAPER IS DATED JULY 8, 1813, AND IS ONE OF MANY ADS THAT THE SCRIBNER BROTHERS PLACED IN EASTERN NEWSPAPERS TO PROMOTE THEIR NEW TOWN.

1815 1816 1817 1818 1819

1816
Indiana becomes the nation's nineteenth state. Jonathan Jennings is elected the state's first governor.

1818
The *Ohio* is the first steamboat built in New Albany. Nathaniel Scribner dies on his way home from orchestrating the creation of Floyd County.

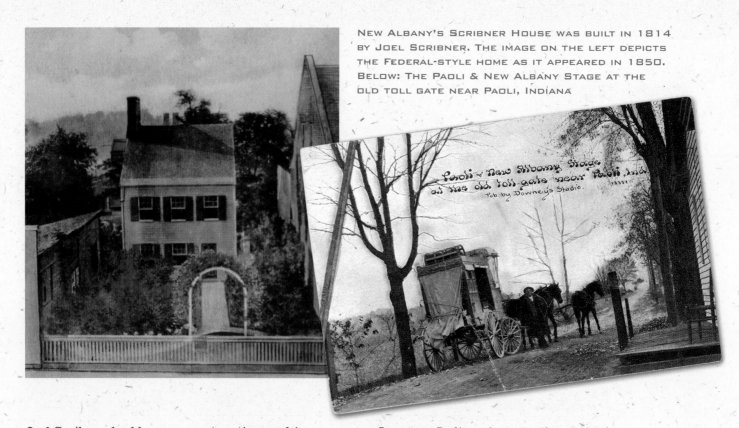

New Albany's Scribner House was built in 1814 by Joel Scribner. The image on the left depicts the Federal-style home as it appeared in 1850. Below: The Paoli & New Albany Stage at the old toll gate near Paoli, Indiana

Joel Scribner had begun construction on his own permanent family home, the first frame structure in town, at the corner of present-day State and Main Streets. Each lot could be paid for in four equal annual installments, with interest deposited in escrow for use by the public school system. Once $5,000 was accumulated in this fund, the sum could be used for the schools. Specific lots of the town plan were set aside for schools, churches, parks, and public buildings. The first four lots, located at the intersection of State and Spring Streets, were designated as sites for a jail, city hall, courthouse, and schoolhouse.

In 1816, Indiana became the nation's nineteenth state and New Albany's population had grown to around 200 residents. The town was incorporated the following year as part of Clark County. The first schoolhouse, a log, two-story affair with one room on each floor, was soon completed and occupied. Within another year, the region had grown in population to the extent that Nathaniel Scribner and other residents petitioned the new state legislature at Corydon to create a separate county with New Albany as the county seat. Authority was granted on January 2, 1819, for the new

TIME LINE

1820 1821 1822 1823 1824

1820
The first stagecoach route in Indiana is established between New Albany and Vincennes.

1821
The Indiana State Legislature passes an act "Incorporating the New Albany School" and establishing the state's first school system.

entity to be named Floyd in honor of Davis Floyd, a distinguished veteran of the Battle of Tippecanoe, fought in November 1811 between Governor William Henry Harrison's army and a strong Shawnee force.

The county's formation occurred in February, at which time its first officials were named. According to an early history of New Albany written in 1921 by Mary Scribner Davis Collins, a granddaughter of Joel Scribner, "Davis Floyd was made judge and Isaac Van Buskirk, associate; Joel Scribner, clerk and recorder; James Besse, sheriff, and Isaac Stewart, assessor." Unfortunately, Nathaniel Scribner never experienced the new county designation, as he died on December 14, 1818, on his return trip from Corydon.

Early county court meetings were busy ones, with many issues to discuss and much business to conduct. Among the first matters addressed were the appointments of Charles Paxson, Clement Nance Jr., and Jacob Pierroll as commissioners. Seth Woodruff provided his home as a meeting place for court, and commissioners met there until late 1824 when the courthouse was completed at a cost of less than $3,000. Tavern keepers who operated within the county were issued a fee schedule for their services, which read, "For breakfast, 31¼ cents; dinner 34½ cents; supper 25 cents; lodging, per night, 12½ cents; peach or apple brandy and gin, 18¾ cents per pint; Jamaica spirits, per half pint, 84½ cents; corn or oats, per gallon, 12½ cents."

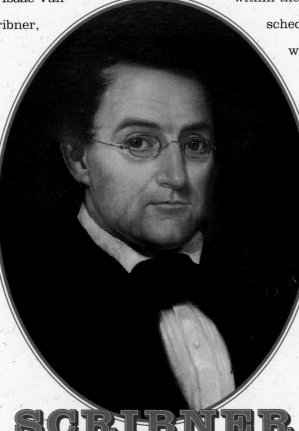

SCRIBNER

NATIONALLY-RECOGNIZED PORTRAIT AND LANDSCAPE ARTIST GEORGE W. MORRISON PAINTED THIS IMAGE OF DR. WILLIAM A. SCRIBNER, JOEL'S SON, IN 1852. DR. SCRIBNER WAS THE UNCLE OF MARY SCRIBNER DAVIS COLLINS, WHO WROTE A HISTORY OF EARLY NEW ALBANY.

1826	1827	1828	1829

1828
Indiana grocery store owners are sanctioned to apply for and receive a liquor license, provided no less than one-half of the affected township's freeholders approve.

1828–1839
John James Audubon publishes his classic *Birds of America* series, depicting native birds, many painted at and near the Falls of the Ohio River and in the Silver Hills of southern Indiana.

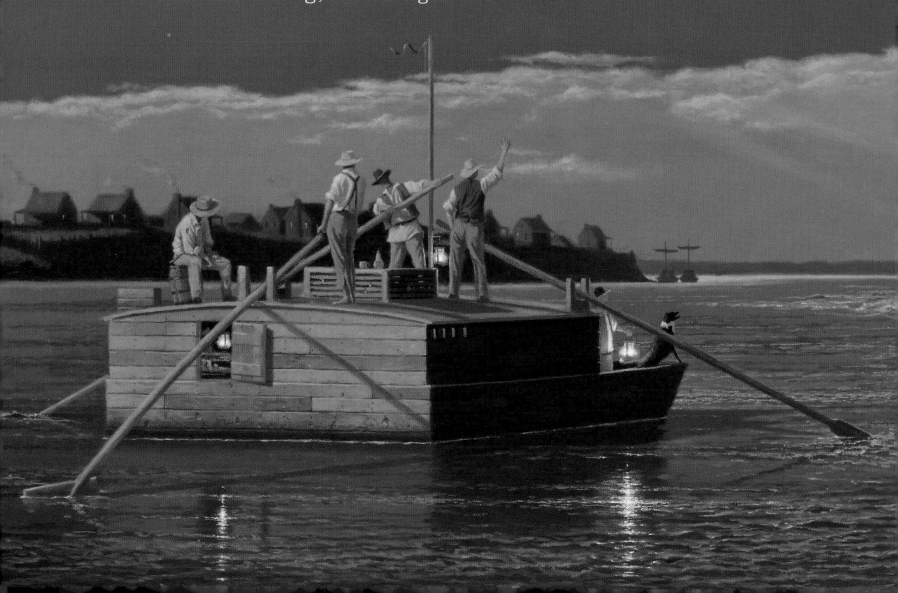

uring late October 1811, an event occurred which would forever affect the fate of the future town of New Albany and the lives of its residents. Nicholas Roosevelt, early kinsman of the presidential Roosevelts, had been hired by Robert Fulton, the owner of the newly organized Ohio Steamboat Navigation Company, to command the first steam-powered vessel to ever travel America's river systems from Pittsburgh to New Orleans. The premier boat was named the *New Orleans*, and it left the wharf at Pittsburgh on October 20, arriving at the Falls of the Ohio sixty-four hours later, averaging eight to ten miles per hour. Among those aboard with Roosevelt were his young wife, Lydia, an engineer, a pilot, "six hands, two female servants, a man waiter, a cook, and an immense Newfoundland dog, named Tiger."

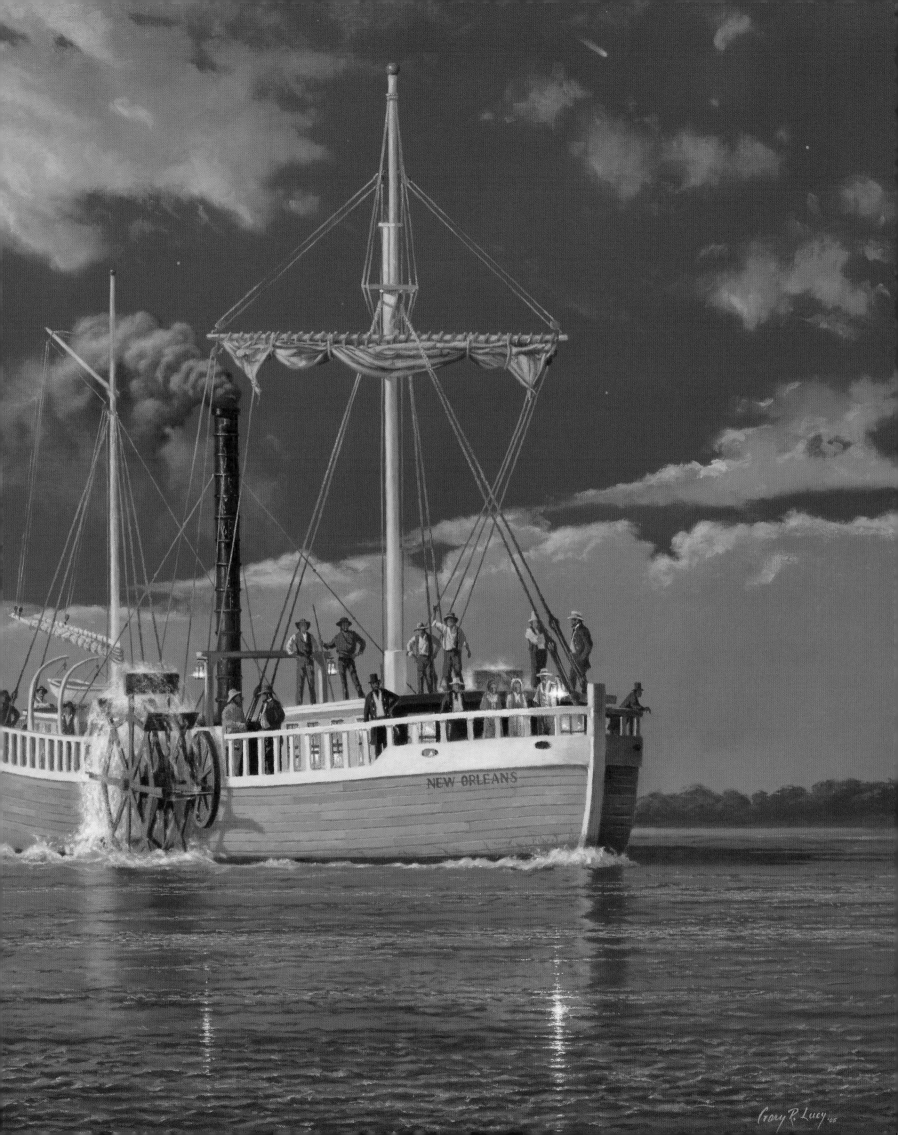

Ia'H. Roosevelt

BEFORE HIS DRAMATIC VOYAGE DOWN THE OHIO AND
MISSISSIPPI RIVERS ABOARD THE *NEW ORLEANS*
IN 1811, NICHOLAS ROOSEVELT (ABOVE) HAD
WORKED FOR SEVERAL YEARS WITH ROBERT FULTON
IN PERFECTING A CRAFT THAT WOULD WITHSTAND
THE STRONG CURRENTS OF AMERICA'S INLAND
WATERWAYS. UNFORTUNATELY, HIS ORIGINAL PRIDE
AND JOY, THE *NEW ORLEANS*, OPERATED ONLY UNTIL
1814, WHEN IT WAS DESTROYED BY A SNAG.

At the Falls of the Ohio, Roosevelt met his first and most difficult obstacle. The water was low and the steamboat could not pass. While waiting for the river to rise, Roosevelt conducted tours back and forth up river, to the delight of scores of enthralled observers. As heavy rains finally came, allowing the boat to pass the Falls, Mrs. Roosevelt bore her second child, and a determined Lydia, with babe in arms, watched from the pilot's house as the *New Orleans* gracefully began its forty-five-minute trip over the cataracts.

The Roosevelt family and its crew next experienced the horror of the New Madrid earthquakes in late 1811. Some settlers along the Ohio River actually believed the severe tremors were caused by the *New Orleans*. One resident, Mary Carson Aston, who lived along the west bank of Silver Creek, upon hearing the huffing and puffing boilers of the boat, thought that Indians were attacking. Upon his arrival in New Orleans on January 10, 1812, eighty-two days out of Pittsburgh, Roosevelt had proven once and for all that steamboats provided a fast, reliable, and comfortable means of transportation and communication along America's inland waterways.

Following New Albany's establishment in 1813, the town's businessmen wasted no time in getting involved in America's newest industry: steamboat construction. The region around the infant town was ideal, with rich forests that provided strong wood for hulls, and abundant small tributaries to the Ohio River upon which

TIME LINE

1830 1831 1832 1833 1834

1832
Kaiser's Tobacco, New Albany's oldest existing business, is founded.

1832
Elias Ayres and Harvey Scribner establish New Albany's first bank, the New Albany Insurance Company.

the cut logs could be floated to the boatyards. In 1818, one such businessman, Joel McLeary, started to build the *Ohio*, a small steamboat said to be about the size of a ferryboat. McLeary was soon followed by other builders, among them George Armstrong, John Evans, Martin Himes, D. M. Hooper, Matthew Robinson, Peter Tellon, and, perhaps the most famous of them all, Henry Shreve.

According to steamboat historian Leland R. Johnson, "Shreve was a colorful character who had begun his career on the waterways as a keelboatman, and perhaps this back-breaking experience explained his keen interest in the development of a steamboat specially adapted to the conditions on the western waters—one with the engine on the deck instead of below it, which floated on the water rather than in it, and which had the paddle wheel at the stern instead of the sides."

Early on in America's steamboat experience, it became clear that logjams, debris, and "snags" in the nation's rivers presented a major obstacle to rapid and safe transportation. During a five-year period in the 1820s, this mounting trash cost steamship owners nearly $1,400,000, and Henry Shreve, then the superintendent of Western River Improvements, decided to do something about

the staggering losses. In 1829, he designed and launched from New Albany the *Heliopolis*, a "snag boat" which was capable of ramming snags in the water, dislodging them from the river's bottom, and lifting them to the deck where they were sawed into fuel for the boat's boilers. Losses from river debris over the next five-year period were reduced by more than two-thirds.

HENRY SHREVE (RIGHT), FOR WHOM SHREVEPORT, LOUISIANA IS NAMED, WAS MOST NOTED FOR THE INVENTION OF THE SNAG BOAT, A CRAFT WHICH PLUCKED SUNKEN LOGS AND OTHER DEBRIS FROM THE RIVER, THUS CLEARING THE BLOCKED CHANNEL FOR PASSAGE. ABOVE IS PICTURED AN EARLY WOODCUT OF THE NEW ALBANY SNAG BOAT, THE *HELIOPOLIS*.

1836
The New Albany-Paoli Turnpike is established, transporting passengers and mail.

1839
New Albany is incorporated as a city.

The Lucy Walker Disaster

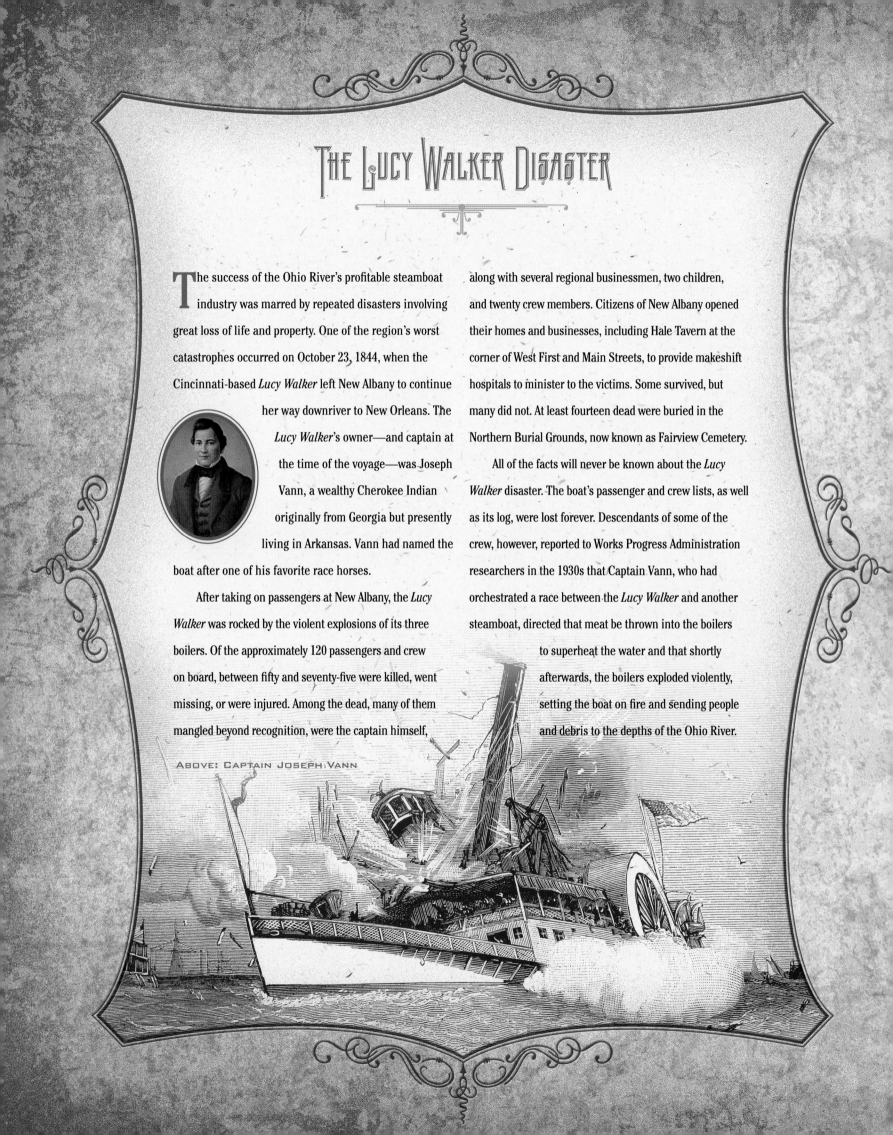

The success of the Ohio River's profitable steamboat industry was marred by repeated disasters involving great loss of life and property. One of the region's worst catastrophes occurred on October 23, 1844, when the Cincinnati-based *Lucy Walker* left New Albany to continue her way downriver to New Orleans. The *Lucy Walker*'s owner—and captain at the time of the voyage—was Joseph Vann, a wealthy Cherokee Indian originally from Georgia but presently living in Arkansas. Vann had named the boat after one of his favorite race horses.

After taking on passengers at New Albany, the *Lucy Walker* was rocked by the violent explosions of its three boilers. Of the approximately 120 passengers and crew on board, between fifty and seventy-five were killed, went missing, or were injured. Among the dead, many of them mangled beyond recognition, were the captain himself,

ABOVE: CAPTAIN JOSEPH VANN

along with several regional businessmen, two children, and twenty crew members. Citizens of New Albany opened their homes and businesses, including Hale Tavern at the corner of West First and Main Streets, to provide makeshift hospitals to minister to the victims. Some survived, but many did not. At least fourteen dead were buried in the Northern Burial Grounds, now known as Fairview Cemetery.

All of the facts will never be known about the *Lucy Walker* disaster. The boat's passenger and crew lists, as well as its log, were lost forever. Descendants of some of the crew, however, reported to Works Progress Administration researchers in the 1930s that Captain Vann, who had orchestrated a race between the *Lucy Walker* and another steamboat, directed that meat be thrown into the boilers to superheat the water and that shortly afterwards, the boilers exploded violently, setting the boat on fire and sending people and debris to the depths of the Ohio River.

Perhaps the most famous steamboat built at New Albany was the legendary *Robt. E. Lee*. When it was launched from the Hill, Roberts, and Company shipyard in 1866, a reporter for the *New Albany Ledger* wrote,

The cabin and outfit of this great southern steamer surpasses that of any boat that ever graced the trade, and her accommodations are on the same scale of grandeur and magnificence. The cabin with its rich garniture and splendid furniture, dazzling chandeliers, arched and fretted ceilings etched with gold, stained glass skylights, immense mirrors, the velvet carpets, the pure zinc white of the sides, the rosewood stateroom doors, the imitation Egyptian marble sills, all combined, make it bear an appearance of oriental luxury, magnificence and splendor seldom conceived and never before seen floating the cold waters of this so-called semi-barbarian Western world.

Built at a cost of $180,000, the vessel measured three hundred feet long with a beam of forty-four feet and was powered by two coal-burning engines, one for each of the boat's two side paddle wheels. With the Civil War still on the minds of New Albanians, and the boat about to be christened in honor of the Confederacy's most prominent general, the builder determined that it might be wise to float the craft across the Ohio River to the Kentucky side where its name was painted upon its stern.

The boat-building industry in New Albany benefited many more individuals than the yard owners, carpenters, machinists, blacksmiths, and engine makers who worked directly with the boats. Ancillary workers—blacksmiths, decorators, cabinetmakers, iron and brass fixture makers, painters, metal smiths, furniture makers, carpet weavers, and textile manufacturers—also contributed their talents

THE *ROBT. E. LEE* WAS NEW ALBANY'S PREMIER STEAMBOAT. THE DECORATIVE SILVER PITCHER WAS REFLECTIVE OF THE CRAFT'S GRANDEUR.

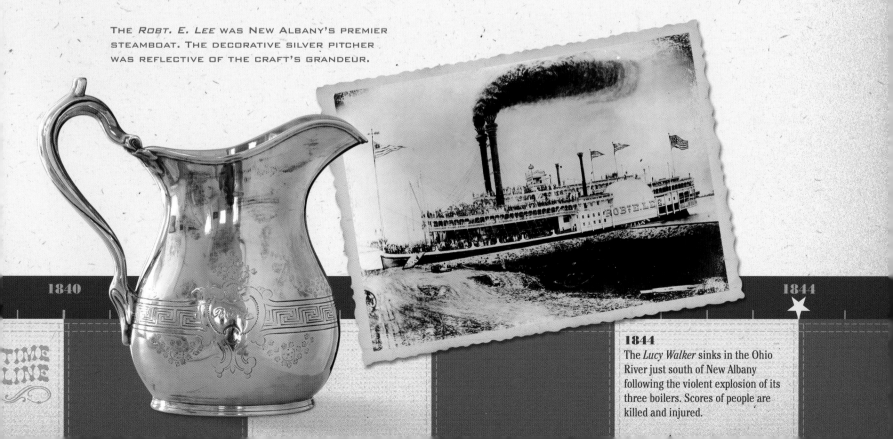

1840

1844

1844
The *Lucy Walker* sinks in the Ohio River just south of New Albany following the violent explosion of its three boilers. Scores of people are killed and injured.

TIME LINE

to providing New Albany's steamboats with some of the finest interior and exterior décor in the United States. Estimates of the times reveal that during the town's steamboat-building peak, seventy-five percent of the local population was in one way or another dependent upon the boat industry.

Steamboat construction was New Albany's first commercial industry. From its beginnings in 1818, it prospered for more than half a century, sometimes supporting numerous boatyards at any given period, launching upwards of 450 boats, and providing a multi-million-dollar boost to the town's economy. In the peak year of 1856, twenty-two boats were launched from New Albany's yards, placing the town second only to Pittsburgh as the nation's most prolific boat-producing city.

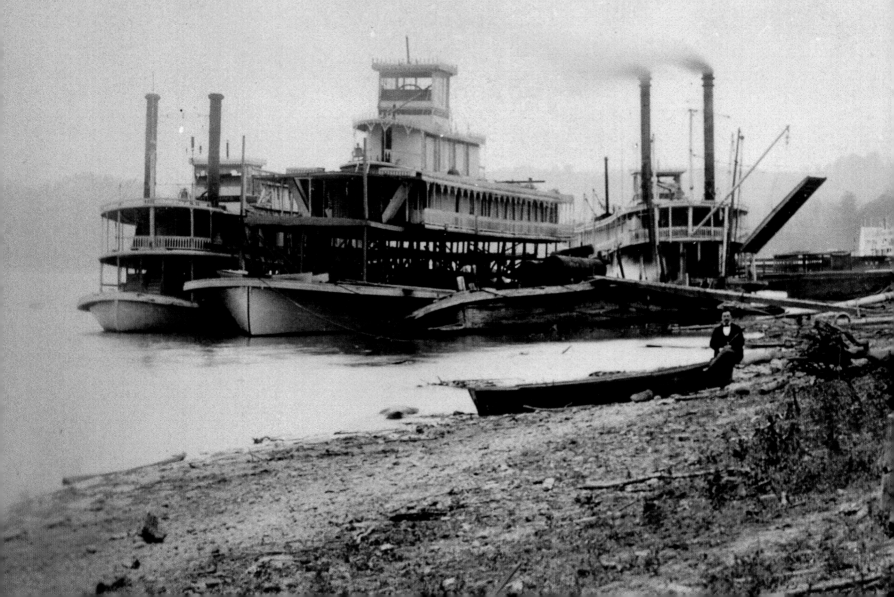

The short-lived financial panic of 1857 spelled doom for many boat builders up and down the Ohio River, including a few in New Albany. In many cases, tight credit measures prohibited boatyard owners from borrowing the funds required to keep their businesses open. Coupled with the increasing popularity of the railroad as a means of both travel and transportation, these were obstacles that simply could not be overcome. By 1880, only one boatyard remained at New Albany, the St. Louis firm of Murray and Hammer. One year later, that builder's final product, appropriately named the *Saint Louis*, was placed into service.

NEW ALBANY'S RIVERFRONT WAS LINED WITH NUMEROUS SHIPYARDS. HUNDREDS OF STEAMBOATS WERE BUILT HERE BETWEEN THE YEARS 1818 AND 1881. IN 1856, ONLY PITTSBURGH PRODUCED MORE STEAMBOATS THAN NEW ALBANY.

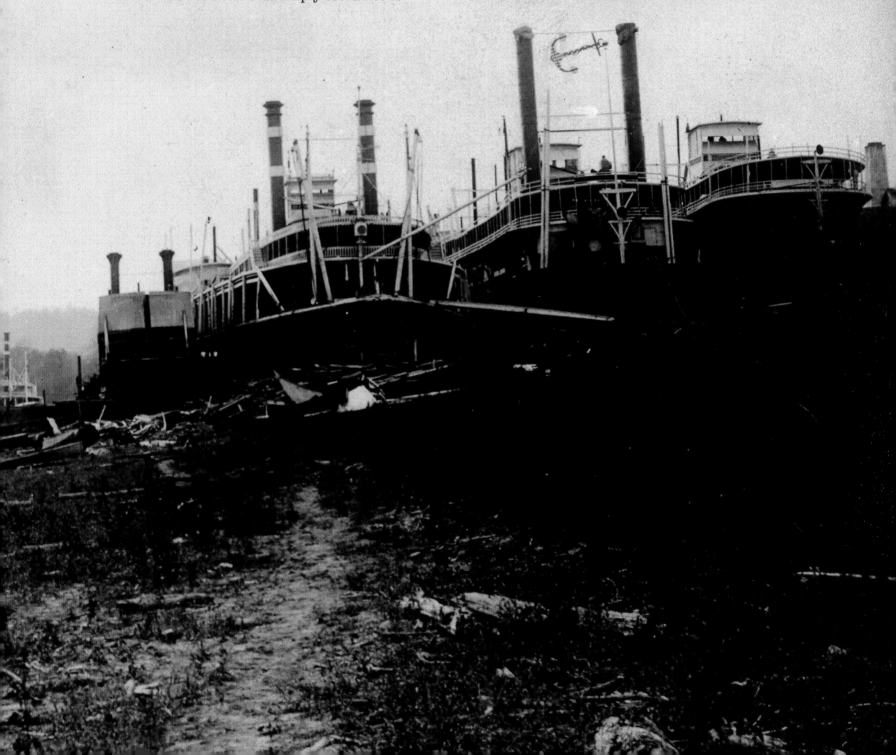

During its early years, although still a small town on the cusp of the frontier, New Albany experienced rapid growth. In 1953, one of the town's preeminent historians, Dr. Victor M. Bogle, wrote in the *Indiana Magazine of History* that,

By the year 1830 the tiny river bank settlement, established just seventeen years earlier, had become not only Indiana's most important point on the Ohio River but its most populous town as well. For thirty years the prestige that comes with being the state's "biggest" and "most important" town was to be New Albany's.

From the mid-1830s with a population of around 2,500, the village grew to more than 4,200 by 1840, and nearly doubled in size during the next decade. By 1850, it had not only maintained its number one place in population but also boasted 1,200 houses, twenty-five percent of them brick. From a business and industrial position, the town supported three iron foundries and machine shops, a brass foundry, two printing companies, a hemp bagging factory, an office of the State Bank, and around 120 retail and grocery establishments, not to mention the several boatyards. Three public and several privately-run schools, as well as a theological seminary and Anderson's Collegiate Institute, provided secondary educations. A railroad connecting New Albany with Salem, located some twenty-five miles northwest, operated out of its depot at the corner of Pearl and Oak Streets.

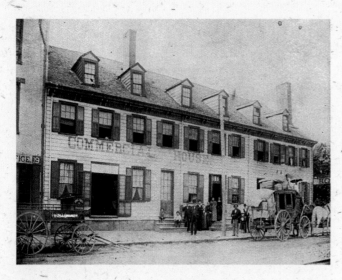

LOCATED ON THE SOUTHEAST CORNER OF WEST 1ST AND MAIN STREETS, THIS TAVERN WAS BUILT IN 1817 BY MRS. JOEL SCRIBNER, WIFE OF ONE OF NEW ALBANY'S FOUNDERS.

THE NEW ALBANY & SALEM RAILROAD WAS FOUNDED IN NEW ALBANY IN 1847. THE RAILROAD WOULD LATER BECOME KNOWN AS THE MONON, *THE HOOSIER LINE.*

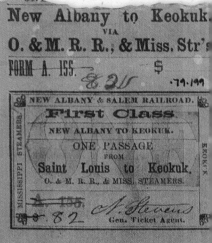

TIME LINE

1847
The New Albany & Salem Railroad, later known as the Monon, is organized on July 8, and would eventually operate with 287 miles of track from the Ohio River to Lake Michigan.

1847
New Albany population is 8,000, making it the largest city in Indiana at the time.

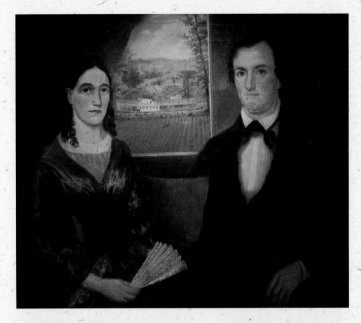

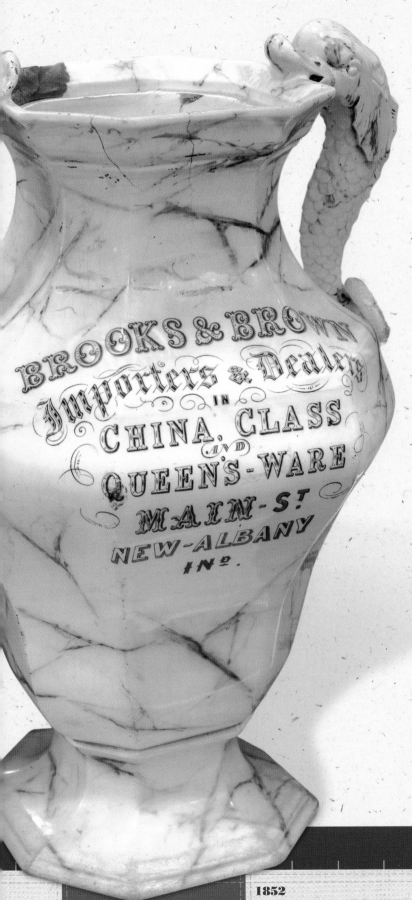

THE PORTRATITS ABOVE WERE EACH PAINTED BY NEW ALBANY ARTIST GEORGE W. MORRISON. TOP: GEORGE LEE HOSEA AND PAMELA MAYNARD-WILLIAMS HOSEA, PAINTED IN 1848. ABOVE LEFT: MARGARET ANN BURNETT, WIFE OF GENERAL ALEXANDER S. BURNETT, LOCAL BUSINESSMAN, SHERIFF, AND MAYOR OF NEW ALBANY, PAINTED IN 1844. ABOVE RIGHT: GEORGE HENRY DEVOL AT AGE FOUR OR FIVE, PAINTED IN 1845.

LEFT: JAMES BROOKS AND JESSE J. BROWN HAD THEIR CHINA, GLASS AND QUEENSWARE COMPANY ON EAST MAIN STREET IN DOWNTOWN NEW ALBANY. THEY WERE ONE OF THE MANY BUSINESSES THAT HELPED SUPPLY THE NUMEROUS STEAMBOATS MANUFACTURED HERE.

1852 1853 1854

1852
The Second Presbyterian Church is completed. Over the next decade, it would become New Albany's most important "stop" on the Underground Railroad.

1853
New Albany High School, funded by interest from the Scribner Fund and initially named Scribner High School, opens as the first public high school in Indiana.

Beer Manufacture in New Albany

The art of brewing beer in the Ohio River Valley began with the arrival of pioneers during the last decades of the eighteenth century. As the region lured European immigrants during the mid-nineteenth century, beer manufacture expanded greatly and became more precise. The post-Civil War era brought with it mechanical refrigeration and improved transportation methods which, in turn, contributed to increased production and distribution. Following Prohibition (1919–1933), when many regional brewers closed their doors, beer manufacture was rejuvenated, only to decline again during the latter half of the twentieth century when the major beer brewers dominated the scene. Today, a growing micro-brewery industry has revived the art of beer production in the region.

By the late 1880s more than five breweries operated in New Albany, one of the most prominent being the Paul Reising Brewing Company (pictured below). The business opened in 1861 on West Fourth Street between Spring and Market Streets on the site of a former brewery operated by Bottomley and Ainslie. Paul Reising, born in Bavaria in 1819, was an experienced brewmaster and his operation grew steadily, from a staff of five employees and a production of thirty barrels a day in 1868, to thirty employees, including two traveling salesmen, and an annual output of 25,000 barrels in 1913.

Hard financial times in 1914 forced Reising into bankruptcy, and his successor, the Southern Indiana Brewing Company, faced the reality of Prohibition five years later. The new company evolved into the Southern Indiana Ice Company, then, following the repeal of Prohibition, the Southern Indiana Ice and Beverage Company. The brewery's old buildings later became home to the Polar Ice Company before being razed in 1969 for the construction of a Holiday Inn.

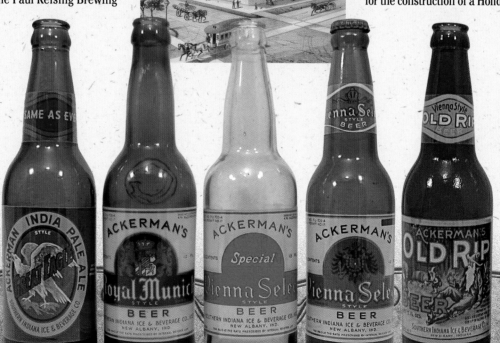

Employees and friends of the Paul Reising Brewing Company, circa late 1870s

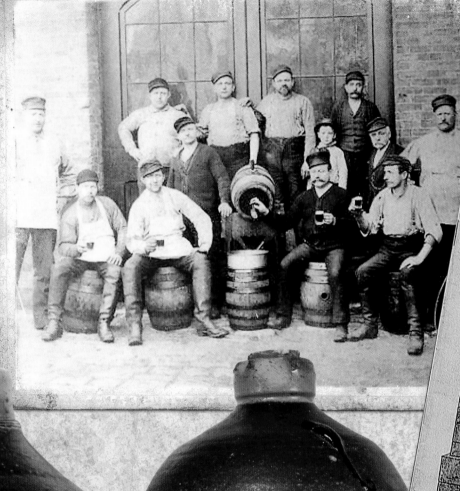

Open Talk

A MAGAZINE OF INTEREST FOR THOSE WHO DRINK BEER AS WELL AS FOR THOSE WHO DO NOT

Published Monthly by
H. L. MEINHARDT, Pres.
Paul Reising Brewing Co.
NEW ALBANY, IND.

THE WUNDERLICH CO NEW ALBANY IND.

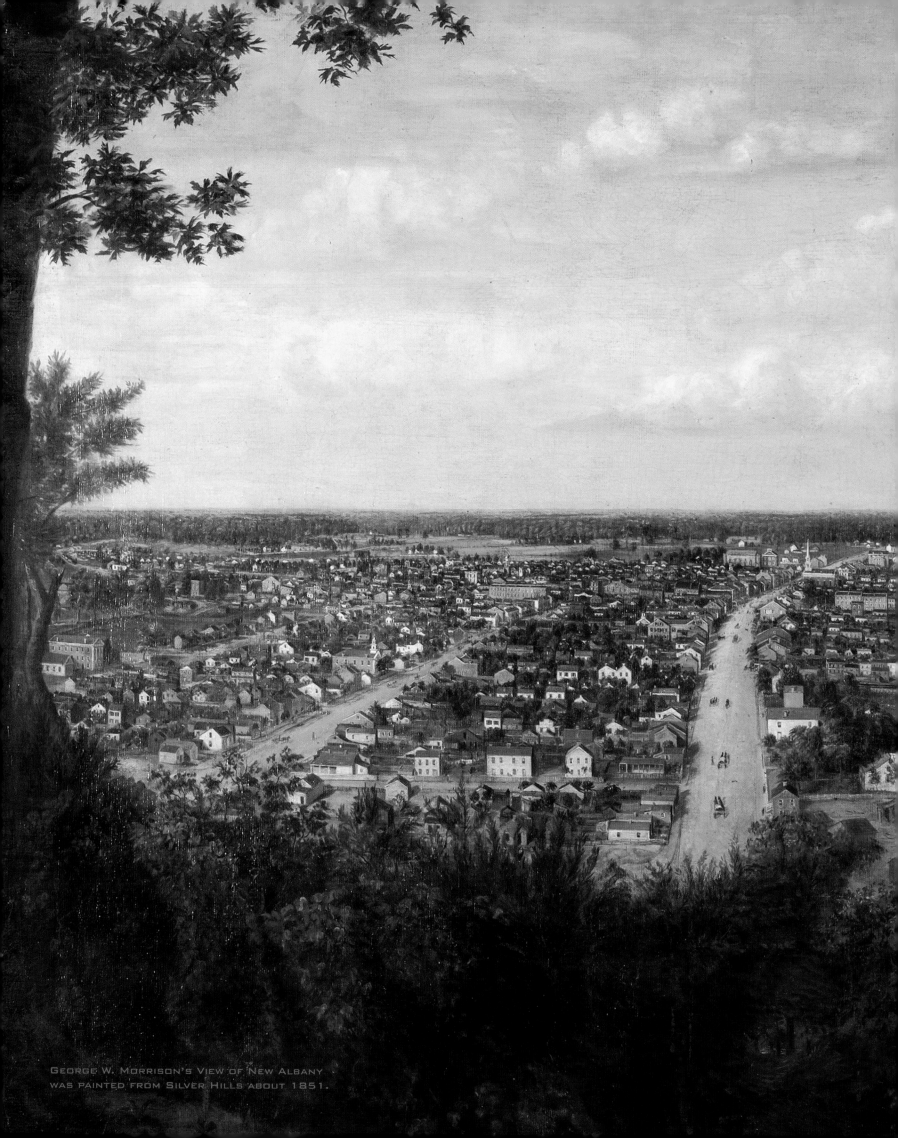

GEORGE W. MORRISON'S VIEW OF NEW ALBANY
WAS PAINTED FROM SILVER HILLS ABOUT 1851.

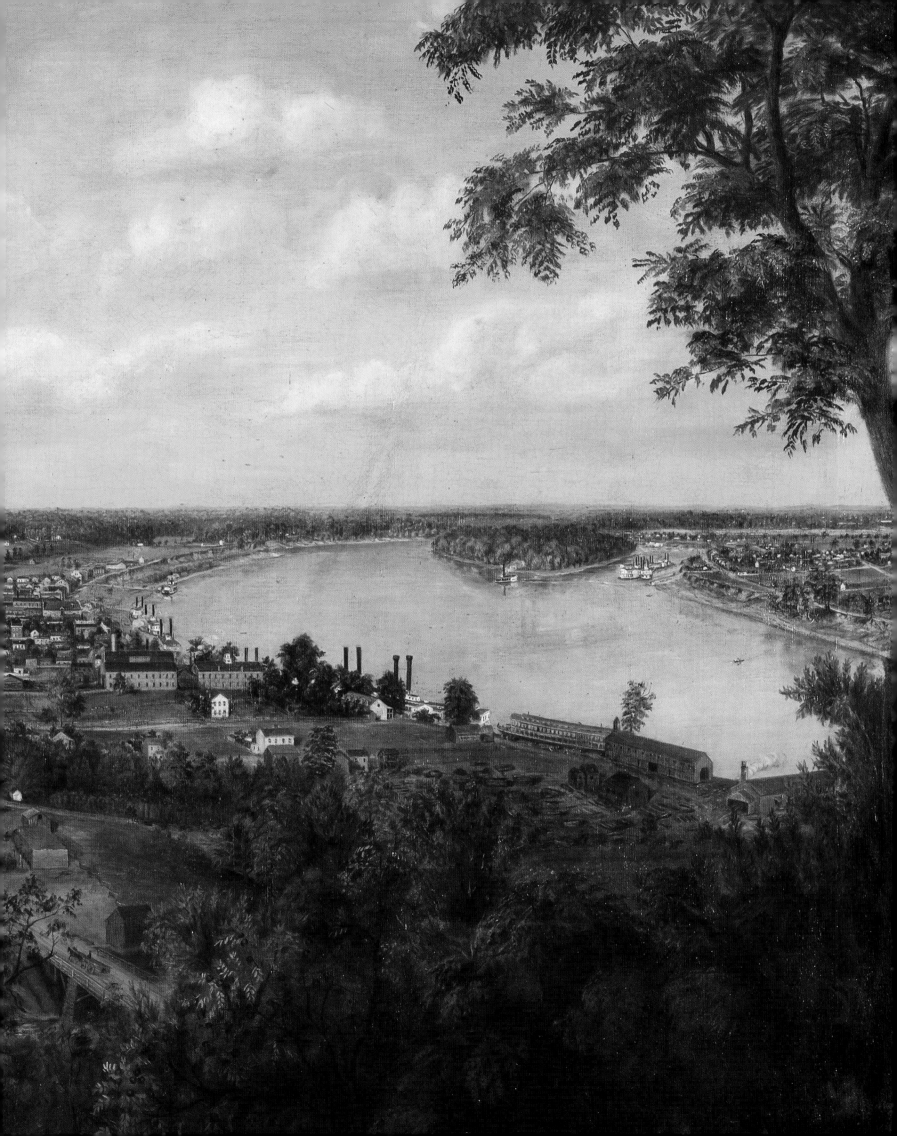

 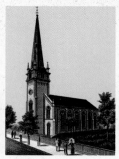 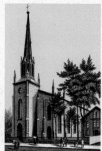 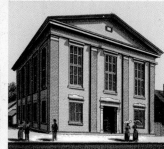 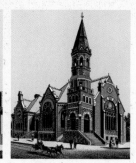

GERMAN METHODIST EPISCOPAL CHURCH

FIRST PRESBYTERIAN CHURCH

HOLY TRINITY CATHOLIC CHURCH

WESLEY CHAPEL METHODIST EPISCOPAL CHURCH

TRINITY METHODIST EPISCOPAL CHURCH

Thirteen Protestant churches and two Catholic churches ministered to the spiritual needs of the community. The unnamed compiler of *Church Histories 1813–1963*, published during New Albany's sesquicentennial in 1963, aptly defined the important role that churches have historically played—and still play—in New Albanians' lives.

Courage, determination and faith were prerequisite to the successful development of a young community along the Urban Frontier of early 19th–Century America. Competition was high...economics were complex and uncertain... customs were changing and unsettled. From the outset, however, New Albany settlers could find solace for their spiritual needs, and strength to continue the difficult struggle of keeping the young town on course in troubled times. And troubled times they were: early financial troubles threatened more than one congregation...

immigration brought an infusion of new culture and a breakdown in communications.... But New Albany and its churches stood the strain together, and the young town grew up to be called "the city of churches."

Like all other American towns and cities, New Albany was now poised at the forefront of a brand-new era. The nation was rapidly approaching civil war, precipitated by the inflammatory issues of states' rights and slavery. New Albany was situated at the crossroads of the nation's slave culture. The Ohio River served as an approximate demarcation line between states recognizing the legality of the institution and those outlawing it. Many plantation owners in neighboring Kentucky, which never seceded from the Union, were heavily involved in both slave ownership and the slave trade. New Albany was a booming city which had strong commercial

1855 1856 1857 1858 1859

TIME LINE

1856
New Albany is second only to Pittsburgh as the nation's premier steamboat manufacturer. Twenty-two boats are launched from its boatyards during the year.

1857
New Albany has five well-organized volunteer fire companies with as many as 365 members and names such as Osceola, Washington, and Hoosier.

ties with the South, primarily as a principal supplier of steamboats used in the cotton trade. Citizens of New Albany, therefore, were very divided on the issue of slavery.

As early as 1822, the winds of change had visited the city, pointing to the day when massive numbers of blacks would flee the South and attempt to find safe haven in the North and in Canada. A Kentucky man wrote in his diary that year of the increasing hostilities between residents in Kentucky and Indiana over the issue of slaves from the Louisville area escaping their servitude by crossing the Ohio to New Albany and their supposed freedom. In 1851, Indiana passed the Exclusion Act, making it

illegal for blacks who were not previous residents to settle in the state. As the 1850s progressed, New Albany became a popular "station" on the Underground Railroad, and with the Civil War rapidly approaching, the black exodus from the South continued. During the late 1850s and early 1860s, Second Presbyterian Church, located at the corner of Main and East Third Streets, served as a symbol of freedom for escaping slaves. Not only could the church steeple be seen from the Kentucky riverbank and used as a landmark, but the strong anti-slavery mandate of the congregation meant it was a place where food, clothing, shelter, and assistance could be found.

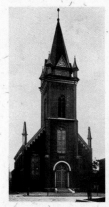

ST. MARKS CHURCH

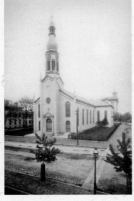

ST. MARY'S CATHOLIC CHURCH

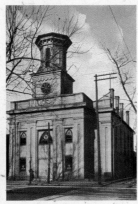

CENTENARY METHODIST EPISCOPAL CHURCH

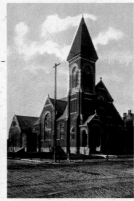

SECOND PRESBYTERIAN CHURCH

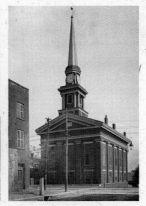

SECOND BAPTIST CHURCH, FORMERLY SECOND PRESBYTERIAN CHURCH

1860 1861 1862 1863 1864

1861
The Civil War begins. Several regiments of Indiana Volunteers are organized in New Albany. Paul Reising opens his brewery on West Fourth Street.

1862
Wounded Union soldiers are brought to makeshift hospitals from the fierce fighting at Shiloh. New Albany becomes the site of one of the country's first of fourteen national military cemeteries.

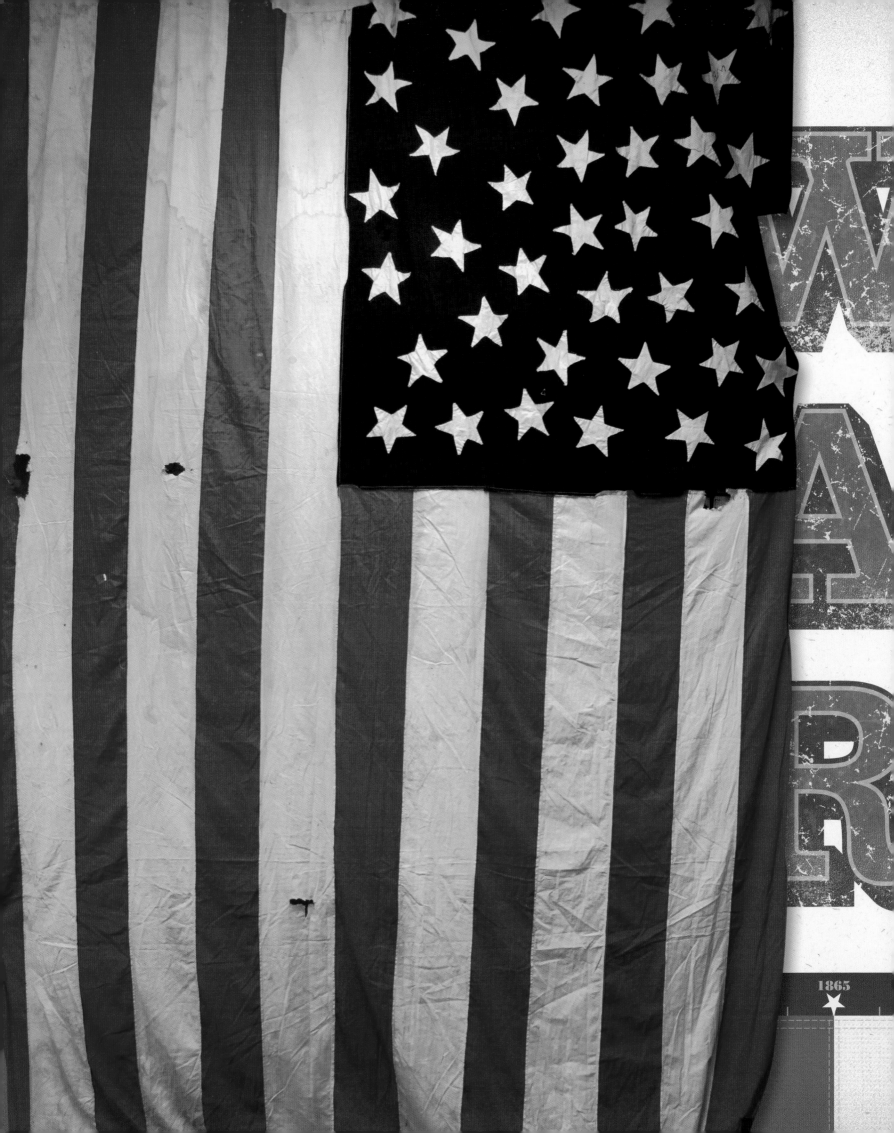

From a personal property standpoint, New Albany fortunately escaped much of the horror and agony of the Civil War. Nevertheless, the town and its citizens contributed much to the Union cause. Camp Noble, an army post located in the present-day Fairmont School section of town, was established and provided the training facility for the 38th Indiana

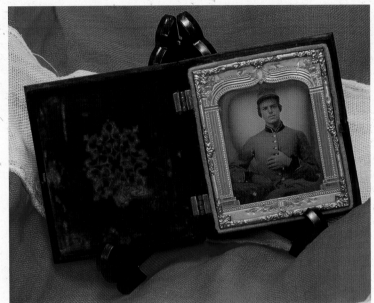

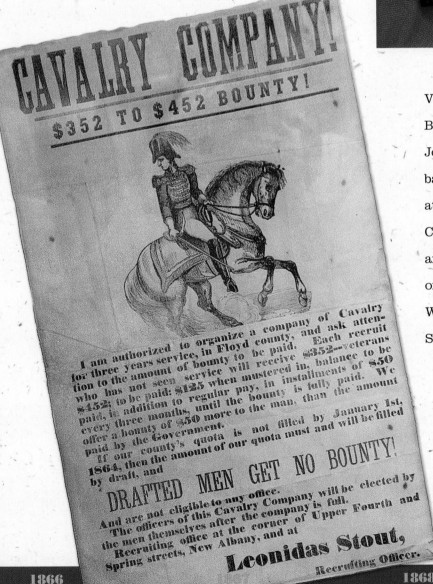

Volunteer Infantry, commanded by Colonel Benjamin F. Scribner, son of the town's founder, Joel. The regiment saw action at several important battles, among them the fierce engagements at Perryville, Kentucky; Stones River and Chattanooga in Tennessee; and Chickamauga and Atlanta in Georgia. Other local regiments of volunteers raised at the time included Colonel William L. Sanderson's 23rd, which fought at Shiloh and Atlanta and which accompanied

ABOVE: DAGUERREOTYPE PHOTO OF PRIVATE SAMUEL CONEY, U.S. ARMY 1861-63
LEFT: RECRUITING POSTER FOR THE FORMATION OF A COMPANY OF CAVALRY FOR THREE YEARS SERVICE IN FLOYD COUNTY IN 1863 DURING THE CIVIL WAR
OPPOSITE: 38-STAR UNITED STATES FLAG FLOWN OVER THE BUDD FAMILY HOMESTEAD, CA. 1876

1866 1868 1869 1870

1865
New Albanian Charles H. Seston of the 11th Indiana Infantry is awarded the Congressional Medal of Honor.

1870
The first panes of American-made plate glass, made in New Albany at John B. Ford's New Albany Glass Works, are installed at John Hieb's Tailor Shop at 316–318 Pearl Street.

General William T. Sherman on his March to the Sea, and the 81st, which participated in battles at Atlanta, Franklin, and Nashville.

Sergeant Charles H. Seston was a New Albany native who served with Company I of the 11th Indiana Infantry. At the Third Battle of Winchester, in Virginia, on September 19, 1864, Seston was mortally wounded and his body was sent home to New Albany for burial in the Northern Burial Grounds. His obituary in the October 6, 1864, issue of the *New Albany Daily Ledger* read, "Serg't Seston was quite a young man, but a braver heart never beat than his, and in the many battles through which his regiment passed, he bore a gallant part." On April 6, 1865, Sergeant Seston was awarded the Medal of Honor "for gallant and meritorious service in carrying the regimental colors." Less than eighty Indianans have been awarded the Medal since its inception in 1863.

During the heated conflict at Shiloh Church in Tennessee in April 1862, many of the nearly 8,500 Union wounded soldiers were floated in hospital boats down the Tennessee River to the Ohio and up the Ohio to New Albany, where they were housed in eleven make-shift hospitals converted from schoolhouses and other buildings. The continuing need for available space in which to treat the wounded caused the city's school system to close for two years. One of the temporary hospitals, located at the northwest corner of Main and Lafayette Streets, ministered to black wounded, as did a twelfth facility housed in a steamboat moored at the foot of lower Fourth Street. At times, even a dozen hospitals provided insufficient space for the wounded, causing many New Albany residents to offer their homes to the effort. In 1862, New Albany also became the site of one of the first of fourteen national cemeteries established by the president through authorization of Congress. In addition to the wounded who died in New Albany hospitals, several members of the United States Colored Troops (U.S.C.T.) are buried there.

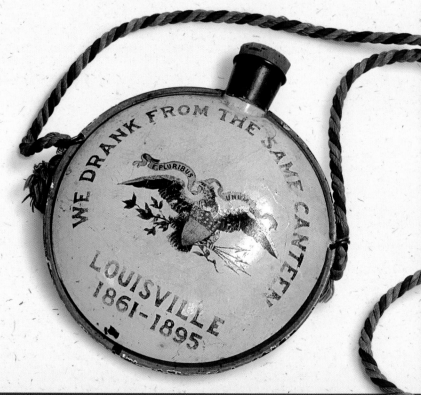

TIME LINE

1871
The Monsch Hotel is completed and opened on September 11, 1871, at the southwest corner of East Market and Bank Streets.

1875
On December 8, New Albany's U.S. congressman Michael Kerr is elected Speaker of the U.S. House of Representatives.

Incident at New Albany

The Reno brothers of Rockford, Indiana, hold the dubious honor of perpetrating the first train heist in the United States and, quite possibly, the world. On October 6, 1866, near Seymour, a small town just a few miles from their home, the brothers—Frank, John, Simeon, Clinton, and William—robbed a train belonging to the Ohio and Mississippi Railroad and walked away with $10,000. A year and a half later, they lifted $96,000 in government bonds and gold from an armored railway car that was part of a Jefferson, Missouri, and Indianapolis Railroad train.

Months later, several of the Reno gang were captured in Canada, but were soon extradited to the United States. Brothers Frank, William, and Simeon, along with gang member Charlie Anderson, were eventually sent to the New Albany jail for safekeeping. The outlaws' presence raised the ire of the Seymour-based Southern Indiana Vigilance Committee, whose members vowed to eliminate the Renos once and for all. They succeeded during the wee morning hours of December 12, 1868, when they appeared in New Albany, stormed the jailhouse, inadvertently shot Floyd County sheriff Thomas Fullenlove, and hanged the outlaw foursome.

Nine days following the lynching, the Vigilance Committee published a stern warning to other lawless elements in southern Indiana who might have failed to get the message. The proclamation read that if future lawbreakers "commence their devilish designs against us, our property, or any good citizen of this district, we will rise but once more; do not trifle with us; for if you do, we will follow you to the bitter end; and give you a 'short shrift and a hempen collar.'"

FLOYD COUNTY JAIL, LOCATED AT THE NORTHEAST CORNER OF STATE AND SPRING STREETS

HEADQUARTERS SOUTHERN INDIANA, VIGILANCE COMMITTEE.

TO THE PEOPLE OF THE UNITED STATES!

"SALUS POPULI SUPREMA LEX."

WHEREAS, it became necessary for this organization to meet out summary punishment to the leaders of the thieves, robbers, murderers and desperadoes, who for many years defied law and order, and threatened the lives and property of honest citizens of this portion of Indiana, and as the late fearful tragedy at New Albany testifies that justice is slow, but sure, we promulgate this our pronunciamento, for the purpose of justifying to the world, and particularly to the people of the State of Indiana, any future action which we may take.

We deeply deplore the necessity which called our organization into existence; but the laws of our State are so defective that as they now stand on the Statute Books, they all favor criminals going unwhipt of justice; a retrospective view will show that in this respect we speak only the truth.

Having first lopped off the branches, and finally uprooted the tree of evil which was in our midst, in defiance of us and our laws, we beg to be allowed to rest here, and be not forced again to take the law into our own hands. We are very loth to shed blood again, and will not do so unless compelled in defence of our lives.

A WARNING.

We are well aware that at the present time, a combination of the few remaining thieves, their friends and sympathizers, has been formed against us, and have threatened all kinds of vengeance against persons whom they suppose to belong to this organization. They threaten assassination in every form, and that they will commit arson in such ways as will defy legal detection. The carrying out in whole, or in part, of each or any of these designs, is the only thing that will again cause us to rise in our own defence. The following named persons are solemnly warned, that their designs and opinions are known, and that they cannot, unknown to us, make a move toward retaliation. Wilk Reno, Clinton Reno, Trick Reno, James Greer, Stephen Greer, Fee Johnson, Chris. Price, Harvey Needham, Meade Fislar, Mart Lowe, Roland Lee, William Sparks, Jesse Thompson, William Hare, William Biggers, James Fislar, Pollard Able. If the above named individuals desire to remain in our midst, to pursue honest callings, and otherwise conduct themselves as law abiding citizens, we will protect them always.—If however, they commence their devilish designs against us, our property, or any good citizen of this district, we will follow you to the bitter end; and give you a "short shrift and a hempen collar." As to this, our actions in the past, will be a guarantee for our conduct in the future. We trust this will have a good effect. We repeat, we are very loth again to take life, and hope we shall never more be necessitated to take the law into our own hands.

Dec. 21, 1868. By order of

As the Civil War came to an end, New Albany's first and premier industry, steamboat construction, began to decline. However, the city had little time to mourn the loss before other manufacturing concerns made their debuts. In 1864, the New Albany Woolen Mill opened on the site of present-day New Albany High School, specializing in not only woolen products but cotton goods as well. Within ten years, more than seven hundred women were employed, turning out a variety of wares including blankets, denim material, thread, and yarn. A hosiery operation was added in 1879 and, in less than a decade, had climbed to one of the nation's top producers of boys' footwear and socks.

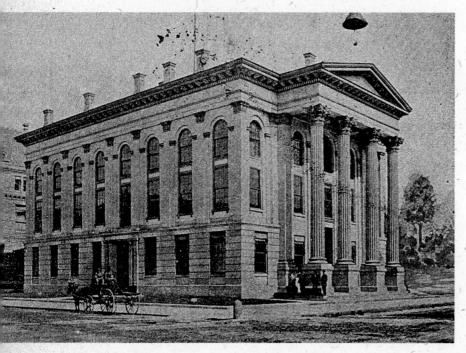

Shortly after the signing of peace at Appomattox Court House, Virginia, in April 1865, John B. Ford, who would later become a partner in the Pittsburgh Plate Glass Company, opened the Star Glass Works at the corner of Water and East Tenth Streets, the first plate glass factory in the United States. Glass making

THE FLOYD COUNTY COURTHOUSE, SHOWN IN THIS CA. 1905 POSTCARD, WAS BUILT IN 1866 IN THE GREEK REVIVAL STYLE OF ARCHITECTURE. IT WAS CONSTRUCTED OF BEDFORD LIMESTONE AT THE SOUTHEAST CORNER OF STATE AND SPRING STREETS FOR $127,700 AND WAS THE THIRD COURTHOUSE FOR THE COUNTY.

TIME LINE

1876 1877 1878 1879 1880

1876
Sanderson No. 3 firehouse, at the southeast corner of East 4th and Spring Streets, is completed and ready for occupancy.

1880
Only one boatyard remains in New Albany, the St. Louis firm of Murray and Hammer.

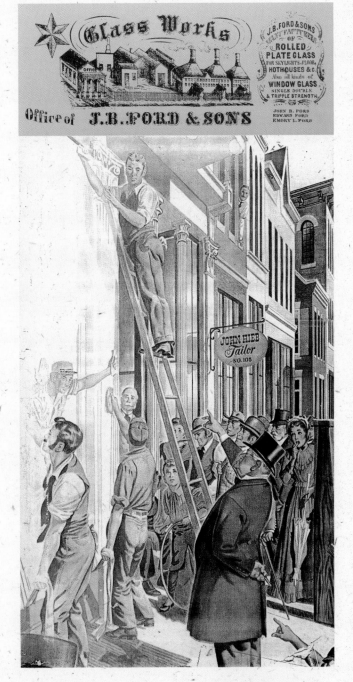

in America dates all the way back to the first settlers at Jamestown, Virginia, but prior to Ford's successful endeavors, plate glass, such as that used in store windows, had to be imported from Europe. Local merchant John Hieb ordered the first pieces of plate glass from Ford's factory to be installed in his tailor shop at 316–318 Pearl Street. In time, Ford sold the glass works to his cousin Washington C. DePauw, arguably the wealthiest person in Indiana, who changed its name to DePauw's American Plate Glass Works. Eventually, the massive plant employed around 2,000 workers, many of them immigrants, and occupied nearly thirty acres along the Ohio River's bank from East 10th to East 14th Streets. It furnished the United States with two-thirds of its plate glass. Upon DePauw's death in 1887, his two sons operated the factory until around 1896.

WASHINGTON C. DEPAUW (LEFT) WAS ONE OF NEW ALBANY'S LEADING CITIZENS AND PHILANTHROPISTS. THE ABOVE LITHOGRAPH DEPICTS CAPT. JOHN B. FORD SUPERVISING THE INSTALLATION OF THE FIRST PIECES OF AMERICAN-MADE PLATE GLASS IN THE STOREFRONTS OF THE JOHN HIEB BUILDING AT 316–318 PEARL STREET IN DOWNTOWN NEW ALBANY.

1881	1882	1883	1884	1885

1880
J.O. Endris Jewelers commences business in New Albany.

1882
Physician Dr. William Burney and educator Joseph Alexander establish New Albany's first African-American newspaper, *The Weekly Review.*

"GO TAKE YOUR BEST GAL,
REAL PAL
GO DOWN TO THE LEVY, I SAID TO THE LEVY,
AND JOIN THAT SHUFFLING THRONG
HEAR THAT MUSIC
AND SONG!
IT'S SIMPLY GREAT, MATE
WAITING ON THE LEVY
WAITING FOR THE
ROBERT E. LEE!"

—L. Wolfe Gilbert

The Race Between the Natchez and the Robt. E. Lee

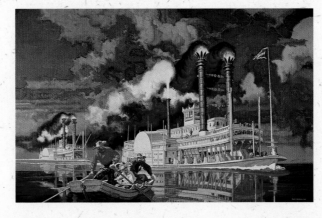

In the annals of steamboat men, Captain Tom Leathers and Captain John Cannon were living legends. As the end of June 1870 rapidly approached, both fiercely competitive men had only recently invested several hundred thousand dollars in their respective steamboat lines. Each bragged that his premier boat—the *Natchez*, owned by Leathers, and the *Robt. E. Lee*, Cannon's pride and joy—was just about the finest, fastest inland water craft to be found anywhere in the world. The time was ripe to determine which captain was correct.

Captain Leathers made a low-key challenge for a race between the two boats when he advertised that the *Natchez* would leave New Orleans for its weekly trip to St. Louis on Thursday, June 30, 1870, rather than on Saturday, the normal departure day. Leathers knew that Cannon's *Robt. E. Lee* always left New Orleans on Thursdays. Thus, by announcing that his boat would also depart the Crescent City on Thursday, Leathers backhandedly issued the dare to Cannon.

Both captains denied the race, although no one believed them, and by five o'clock on the afternoon of the thirtieth, more than ten thousand anxious onlookers crowded the New Orleans wharf. There, separated by only two berths, were the magnificent *Natchez* and *Robt. E. Lee*, both cleaned and polished to perfection and with thick, black smoke belching out of their twin smokestacks.

Cannon got the jump on Leathers, when exactly at five o'clock he ordered the mooring lines dropped from the *Lee* and headed upriver. Leathers, not a little chagrined at being caught napping, cast off in hot pursuit. Before the last view of New Orleans disappeared around a bend of the river, the *Lee* was already one mile, or three and a half minutes, ahead of the *Natchez*. Cannon never looked back and maintained his lead for the entire race.

At 11:35 a.m. on July 4, the *Robt. E. Lee* pulled up to the St. Louis wharf amidst the wild cheering and mirth-making of seventy-five thousand spectators, the largest crowd ever assembled in the city. The time for the twelve-hundred-mile run was three days, eighteen hours, and fourteen minutes.

Many other races between mighty steamboats on America's river systems have been run over the years, but never was there one that caused greater curiosity and generated more interest and excitement than the legendary race between the *Natchez* and New Albany's own *Robt. E. Lee*.

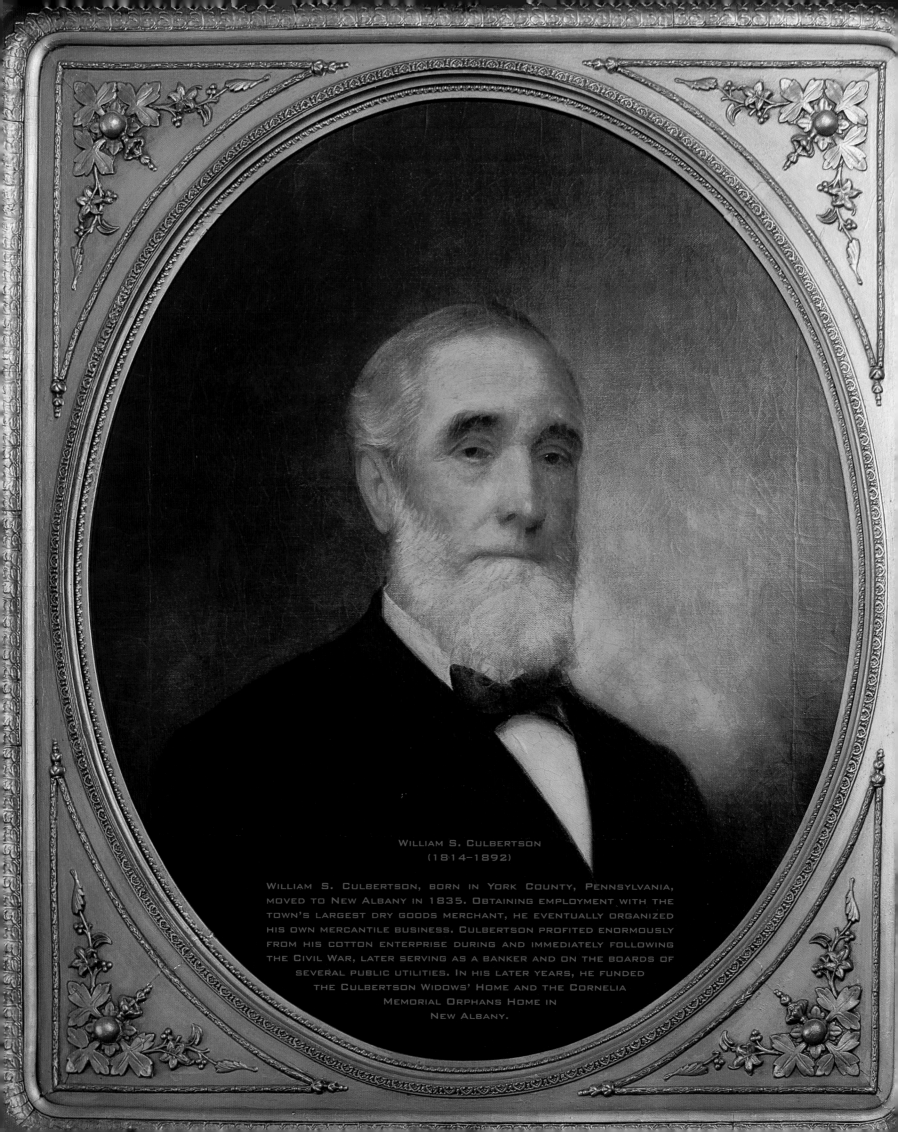

WILLIAM S. CULBERTSON
(1814–1892)

WILLIAM S. CULBERTSON, BORN IN YORK COUNTY, PENNSYLVANIA,
MOVED TO NEW ALBANY IN 1835. OBTAINING EMPLOYMENT WITH THE
TOWN'S LARGEST DRY GOODS MERCHANT, HE EVENTUALLY ORGANIZED
HIS OWN MERCANTILE BUSINESS. CULBERTSON PROFITED ENORMOUSLY
FROM HIS COTTON ENTERPRISE DURING AND IMMEDIATELY FOLLOWING
THE CIVIL WAR, LATER SERVING AS A BANKER AND ON THE BOARDS OF
SEVERAL PUBLIC UTILITIES. IN HIS LATER YEARS, HE FUNDED
THE CULBERTSON WIDOWS' HOME AND THE CORNELIA
MEMORIAL ORPHANS HOME IN
NEW ALBANY.

GOVERNMENT BUILDING AND POST OFFICE

NEW ALBANY GOVERNMENT BUILDING AND POST OFFICE

NEW ALBANY VENEER COMPANY

With the dawn of the twentieth century, New Albany gave rise to several highly successful industries, including furniture, leather production, plywood, and, especially, veneer operations. Providentially, as early as 1856, the New Albany Board of Trade had suggested that such a dynamic industry be pursued when it published in its booklet, *The Commercial and Manufacturing Advantages of New Albany, Ind.*, that,

A mill for sawing all kinds of veneering ought to be a good investment here. We understand that large quantities of timber are being shipped from Henderson, Ky., and other points below this, to Cincinnati, to be sawed up in veneering. Why should not New Albany supply her share of the trade in this line, when she is surrounded with timber of the right kind?

Eventually, New Albany earned the title, "Veneer Capital of the World," and even today is universally recognized for its prodigious output of quality veneer wood products.

The early twentieth century also witnessed the rise of the world's largest prefabricated homes industry. In 1935, Foster Gunnison, a Brooklyn, New York-born entrepreneur who has been called "the Henry Ford of Housing," chose New Albany to be home for his Gunnison Magic Homes Company. Gunnison's "vision of a machine-based housing industry, rather than depending on craftsmen working on single structures" produced "the full benefits of mass-production technology to a backward industry and provide[d] a new level of abundance for society."

ABOVE: THE MIDDLE MARKET HOUSE
LEFT: MULE-DRAWN STREET CAR, CIRCA 1880

1886
Rear Admiral George A. Bicknell of New Albany supervises the construction of the first steel warships used by the U.S. Navy.

1887
Washington C. DePauw, the wealthiest man in Indiana and the owner of the American Plate Glass Works, dies. New Albany's William Culbertson succeeds as wealthiest Indiana citizen.

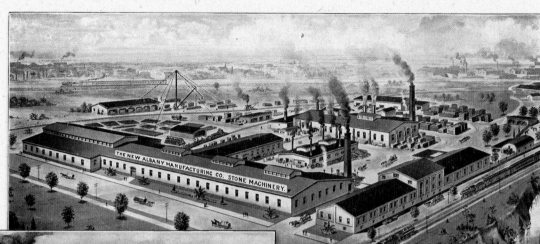

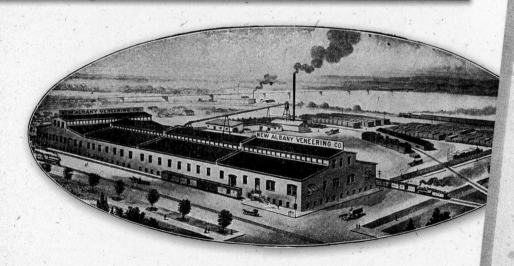

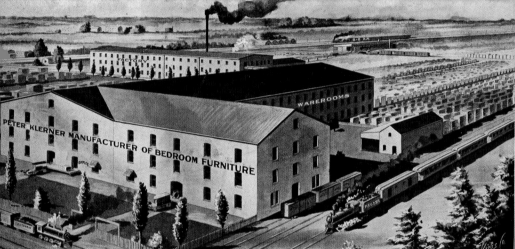

New Albany's location on the Ohio River and its proximity to railroads and natural resources was fortuitous in attaining the status as one of the most dynamic manufacturing centers in the Midwest.

Right: 1893 View from the K&I Bridge

1891 1892 1893

TIME LINE

1898
The First Presbyterian Church is destroyed by fire. A new sanctuary soon rises on the same site on Bank Street.

INDUSTRY

in NEW ALBANY

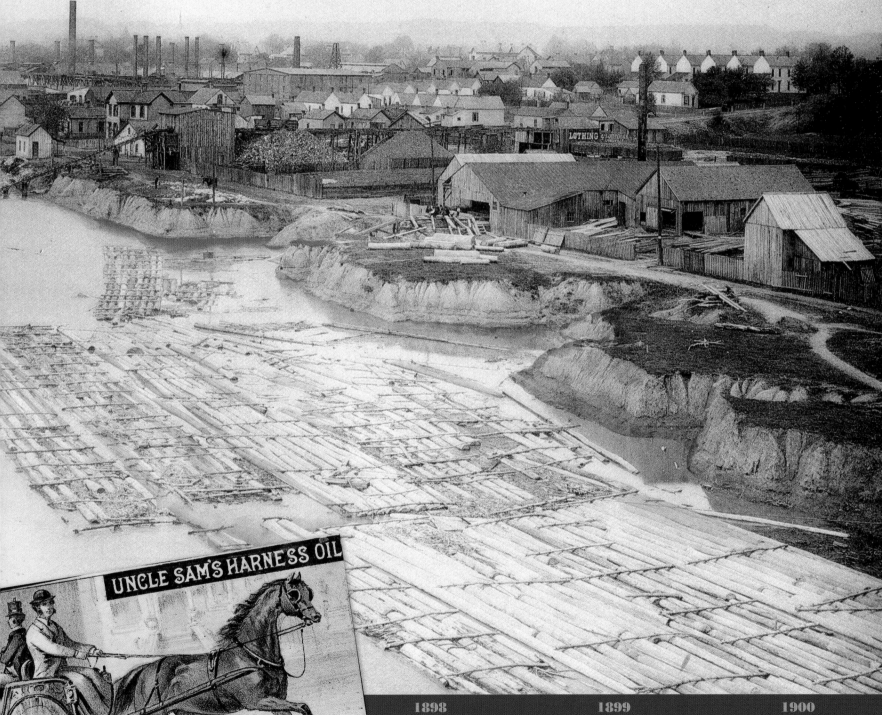

UNCLE SAM'S HARNESS OIL

TULEY, 81 State St.. Bet. Main & Market, New Albany,

...ler in HARNESS, SADDLES, ROBES BLANKETS &c.

1898 1899 1900

1898
New Albany's Lucy Higgs Nichols, a veteran of several Civil War engagements with the 23rd Indiana Volunteer Infantry Regiment, is awarded pension by U.S. Congress.

Escaped Slave to Honored Veteran

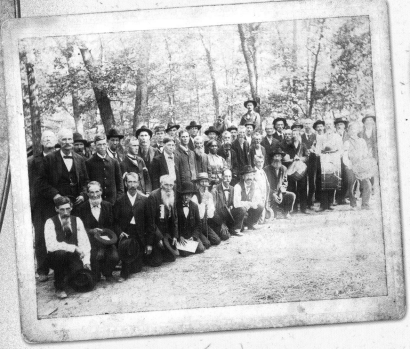

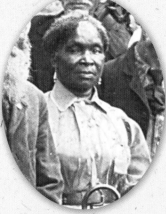

The only known photo of Lucy Higgs Nichols in the center of Civil War veterans attending an 1898 reunion

History has failed to record at precisely what moment young Lucy Higgs decided to escape her servitude on a plantation near Bolivar, Tennessee, and seek freedom. Perhaps it was during early spring 1862, when rumors flew that Union generals Don Carlos Buell and Ulysses S. Grant were about to rendezvous at nearby Pittsburg Landing (Shiloh), where their combined 55,000-man force would go head to head with a 44,000-man army led by General Albert Sidney Johnston. A few months after the great battle at Shiloh in April, Lucy ran away from her owners with her infant daughter, Mona, and came upon a unit of the 23rd Indiana Volunteer Infantry Regiment. For the next three years, she served as a nurse with the 23rd Indiana and witnessed many of the major engagements of the Civil War, including Vicksburg (where her daughter died), Atlanta, and General William T. Sherman's March to the Sea. She was present at the 23rd Regiment's last skirmish at Bentonville, North Carolina, during March 1865.

After the war, Lucy returned with the 23rd Regiment to New Albany, where, in 1870, she married John Nichols. Lucy was made an honorary member of the Grand Army of the Republic (GAR) and, although not officially counted as a veteran, attended many of the 23rd Regiment's reunions. Over the years she participated in veterans' parades and other ceremonies. In 1898, with the advocacy and strong urging of many 23rd Regiment veterans, the United States Congress, through a special act, granted Lucy a monthly pension of twelve dollars for her wartime service. Lucy Higgs Nichols died in 1915 at the County Home on Grant Line Road in New Albany.

During five festive days in October 1913, New Albanians commemorated their 100th birthday, and what a celebration it was. A large part of the business district was decorated with banners, flags, and special lighting, called the "The Grand Illumination." The grand parade featured several bands, 108 specially-built floats, and a huge "human" American flag consisting of 700 local school children. Following a commemorative ride of about one mile down the Ohio River, the great-grandson and three great-great-grandsons of Abner Scribner floated up to the wharf at the foot of Pearl Street, there to be happily welcomed by hundreds of excited onlookers.

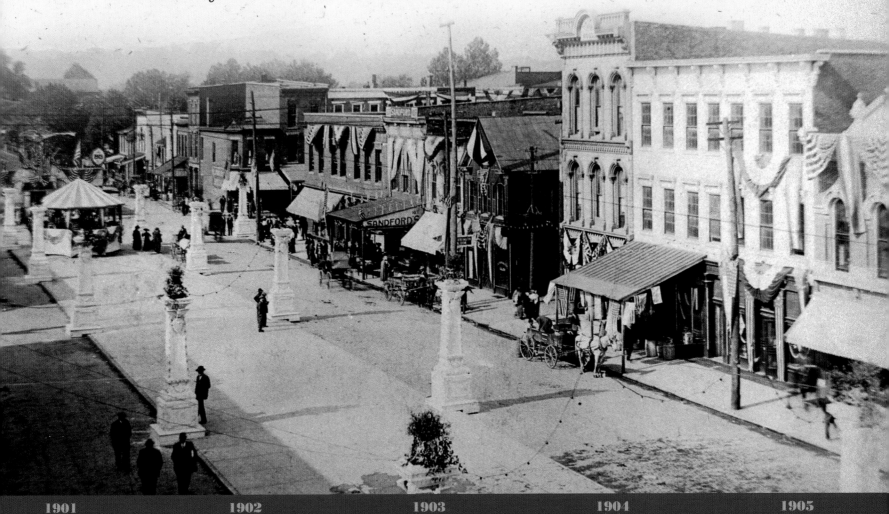

TIME LINE

1901 1902 1903 1904 1905

1904
Using a $40,000 gift from Andrew Carnegie and contributed land and funding from the New Albany City Council, the neoclassic-style Carnegie Library opens.

1904
First Chautauqua held in New Albany at Glenwood Park was on August 5, 1904.

1813 NEW ALBANY 1913

CENTENNIAL

One of the most important events during the Centennial celebration was the *Made in New Albany* exhibition as shown below. At least 90 New Albany companies and businesses showed off the various wares that were manufactured in New Albany at that time.

1813 CENTENNIAL 1913
NEW ALBANY IND

NEW ALBANY

1813

1913

MADE IN NEW ALBANY.

1906 1907 1908 1909 1910

TIME LINE

1908
Aebersold Florist is established in New Albany.

1913
New Albany celebrates its centennial with a visit by Abner Scribner's great-grandson and three great-great-grandsons. Miss Martha L. Enos selected Centennial Queen.

CELEBRATION

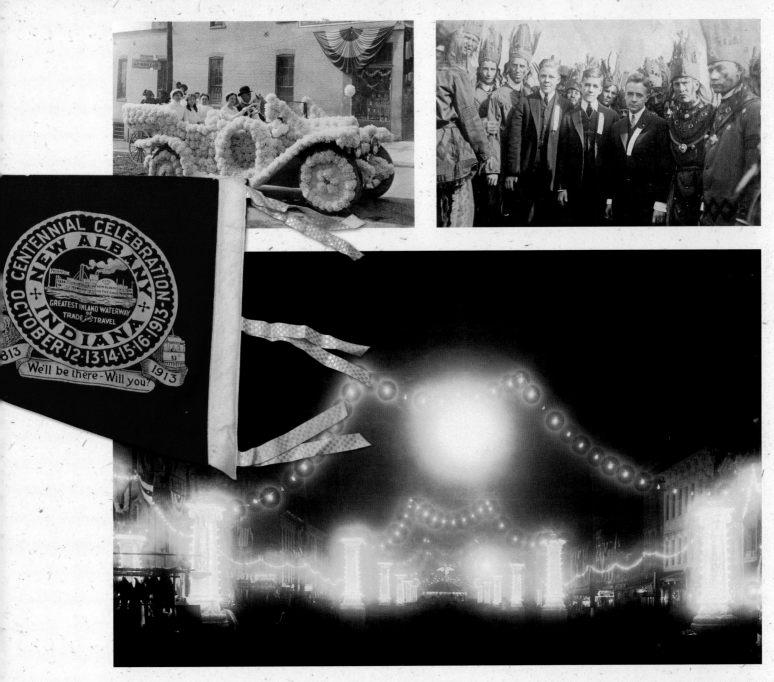

A HUGE PARADE, FEATURING 108 DECORATED FLOATS, TOOK PLACE ON OCTOBER 14TH. THE FESTIVITIES CARRIED ON INTO THE EVENING WITH "THE GRAND ILLUMINATION" OF MARKET STREET AS SHOWN ABOVE.

1911 1912 1913 1914 1915

1913
Fire destroys the Wood Mosaic Flooring Company.

1913–1914
Edwin Hubble, who in his later career will develop the theory of an expanding universe, teaches mathematics, physics, and Spanish at New Albany High School and coaches the boys' basketball team.

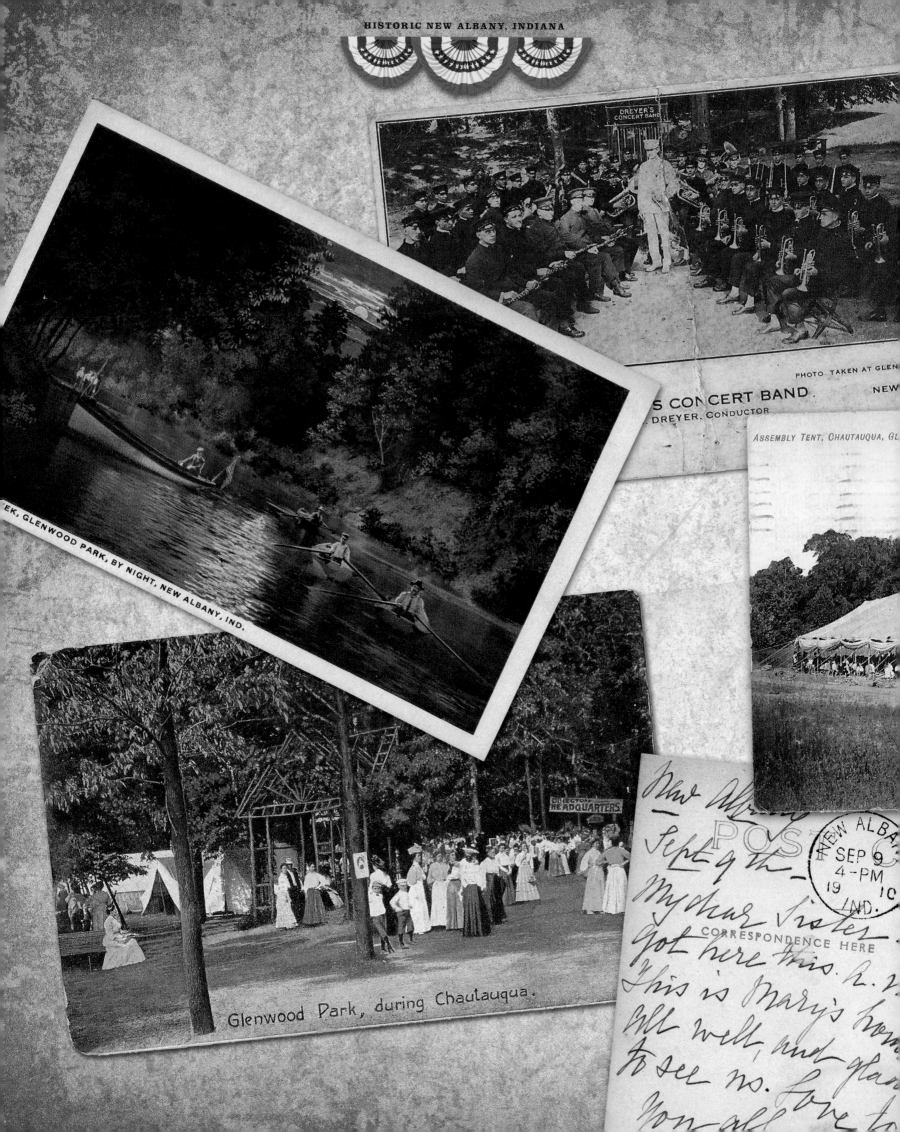

DREYER'S CONCERT BAND

PHOTO TAKEN AT GLEN...

...S CONCERT BAND. NEW...

... DREYER, CONDUCTOR

ASSEMBLY TENT, CHAUTAUQUA, GL...

...EK, GLENWOOD PARK, BY NIGHT, NEW ALBANY, IND.

COLLECTORS HEADQUARTERS

Glenwood Park, during Chautauqua.

POS...
CORRESPONDENCE HERE

NEW ALBA...
SEP 9
4 - PM
19 10
IND.

New Alba...
Sept 9th —
My dear sister
got here this...
This is Mary's...
all well, and...
to see us. Love...
You all...

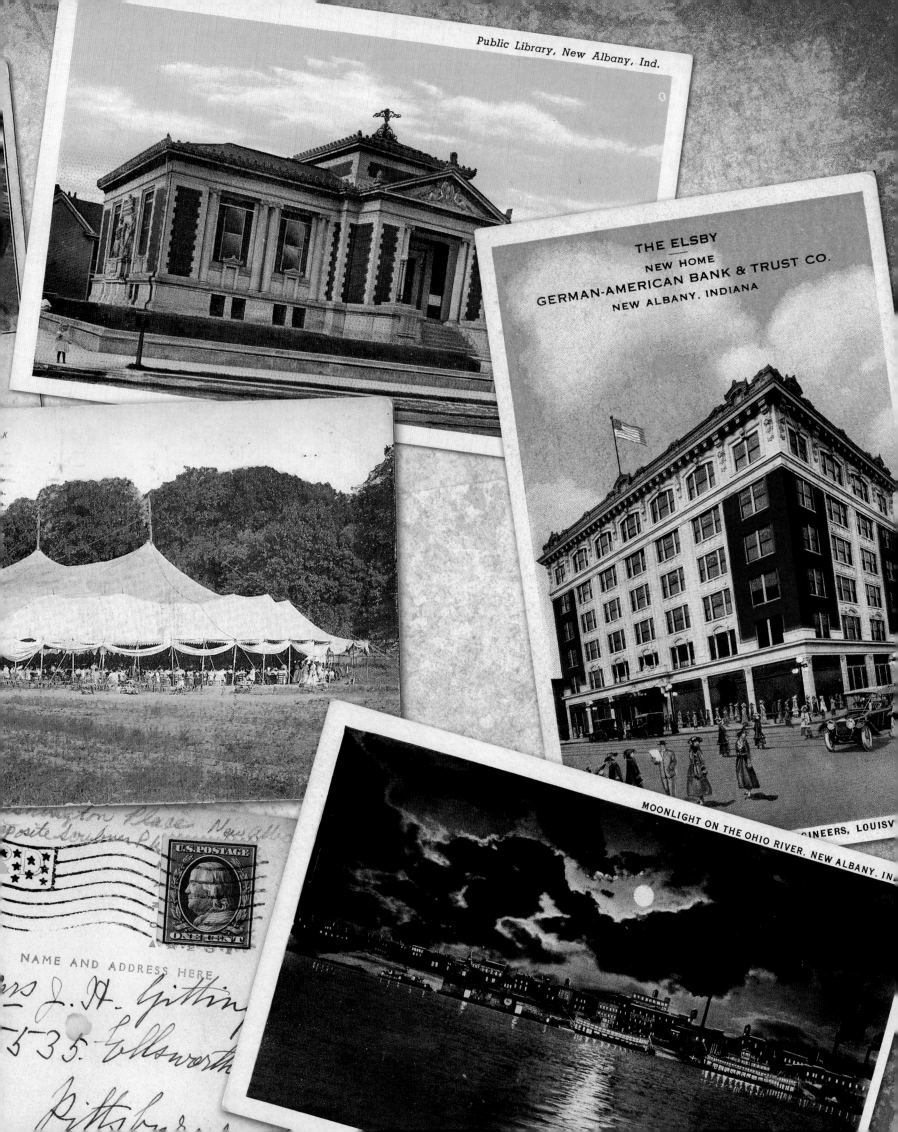

Public Library, New Albany, Ind.

THE ELSBY
NEW HOME
GERMAN-AMERICAN BANK & TRUST CO.
NEW ALBANY, INDIANA

MOONLIGHT ON THE OHIO RIVER, NEW ALBANY, IN

U.S. POSTAGE
ONE CENT

NAME AND ADDRESS HERE

The following year, war broke out in Europe, and in 1917, the United States sent millions of its young men to fight on the battlefields of France. Among the 116,708 Americans killed during the war, thirty-four hailed from Floyd County. Another Floyd County native who served her country in a different way was Grace Leigh Scott, a DePauw University graduate and professional singer. She spent a year in France with the YMCA, ministering to the wounded and sick doughboys. "I sang in many hospitals, sometimes in amputation wards where every patient had lost an arm or leg, or both," she once declared, adding that after the war, she relinquished her music career to pursue a campaign to "save America by building into its youth the finest ideals of character and good citizenship [and to] teach by precept and example the fine art of living."

Over the past two centuries, New Albany has been visited by many calamities. A devastating fire in August 1913 destroyed the Wood Mosaic Flooring Company, the city's second largest employer, along with seventeen nearby homes. Several severe floods—in 1883, 1884, 1907, and 1913—caused havoc from one end of the community to the other and resulted in millions of dollars in damages. In June 1990, multiple tornadoes hit the vicinity, causing considerable property damage. However, the two natural disasters that are most often remembered regarding New Albany are the New Albany Tornado of 1917 and the Ohio River flood of 1937.

TIME LINE

1917
A vicious tornado, sometimes referred to in New Albany as a "cyclone," destroyed a large portion of the city, killing 45 residents and injuring 311 more.

1917–1918
In April 1917, the United States enters World War I, which claims the lives of thirty-four Floyd Countians.

During the warm afternoon of March 23, 1917—two days after New Albanians read in their newspapers that President Woodrow Wilson had called for a special session of Congress to convene on April 2 to consider a declaration of war against Germany—a huge, dark, ominous cloud dropped out of the skies near West Seventh Street. The tornado—locally referred to as a "cyclone"—slashed a path of destruction one-half mile wide, gobbling up scores of homes along its three-mile-long route eastward toward the intersection of Vincennes Street and Charlestown Road. Within hours of the cyclone's appearance, Mayor Robert

THE DEVASTATION WROUGHT ON NEW ALBANY BY THE MARCH 23, 1917 TORNADO, SUCH AS THE SCENE BELOW AT THE INTERSECTION OF CHARLESTOWN AND GRANT LINE ROADS, WAS APOCALYPTIC IN SCOPE.

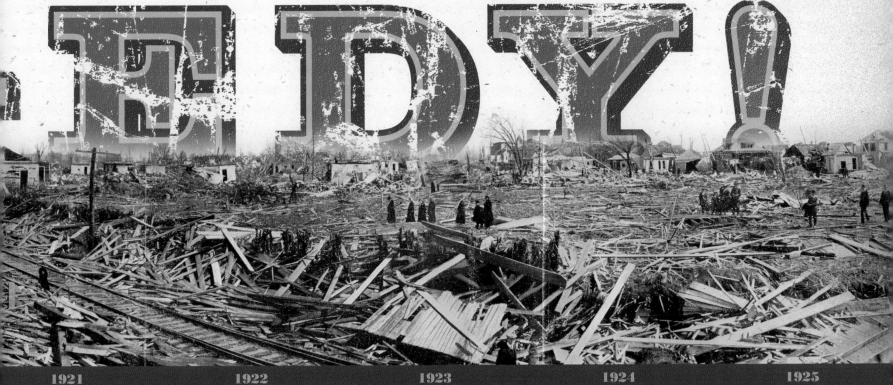

1921 1922 1923 1924 1925

1922
New Albany Country Club, the first golf club in New Albany, is opened as a project of the Young Businessmen's Club of New Albany.

1923
F.W. Woolworth Co. opens the first Woolworth Cafeteria in the country, upstairs at 220 Pearl Street.

Morris formed the "New Albany Citizens Relief Committee," consisting of local business leaders. The first Boy Scout Troop ever organized in the city provided emergency and rescue services, as did the New Albany High School class of 1917, the Red Cross, and units of the Indiana National Guard. Medical facilities at St. Edward Hospital were soon swamped, causing City Hall, the Y.M.C.A., and other public buildings, as well as private residences, to be converted into hospitals and relief stations. In what some modern-day authorities believe to have been at least an F-4, and possibly an F-5, tornado, the storm killed 45 people, injured 311 more, and leveled five factories and 500 residences.

Twenty years after the 1917 tornado, savage floods hit the entire Ohio River Valley, inflicting damages amounting to $3.9 billion (in 2012 dollars) in the fourth costliest deluge ever to hit North America. New Albany was especially hard hit, with waters covering practically the entire downtown area. On January 27, the Ohio crested at an all-time record of 85.48 feet above flood stage, dwarfing the 1907 flood, which posted 69.1 feet above flood stage, and the 1913 flood, which recorded 72.7 feet. Well over one-half of the town's families suffered some kind of damage. According to the *New Albany Ledger*,

[F]orty-eight industrial plants, 319 commercial properties, each housing one or more business units, eleven school buildings and twenty-one churches were in the flooded area. Of the 6,617 residential structures in the city, 3,515 containing 4,236 dwelling units were affected by the flood.

The Great Flood of January 1937 created a state of emergency lasting three weeks. Hundreds of helpful volunteers from the Red Cross, the Civilian Conservation Corps (CCC), the Works Progress Administration (WPA), and the Indiana National Guard, among others, selflessly assisted local residents and businesses. During these trying times, intensified by the lingering economic stresses precipitated by the Great Depression, New Albanians tried to recover from the flood's harsh realities but were painfully stretched to their financial limits.

Within four years of the destructive 1937 flood, the armies of the Third Reich had ravished much of Europe, and the Japanese Empire had bombed the American naval base at Pearl Harbor in the Hawaiian Islands. The United States once again found itself in a world war, this time to be fought on two fronts. Hundreds of Floyd Countians answered the call to military service; 114 never returned. If anything good can be said

1926 1927 1928 1929 1930

1926
Col. Harland D. Sanders, founder of Kentucky Fried Chicken, was living in a rental house at 1720 Florence Avenue.

1927
Grace Lutheran Church was organized on November 25, 1927.

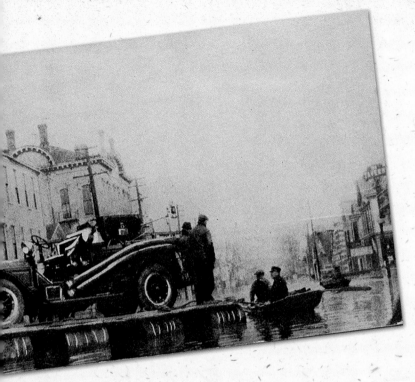

MOUNTED ON PONTOONS, THE NEW ALBANY FIRE DEPARTMENT COULD FLOAT THEIR FIRE TRUCK TO ANY FIRE EMERGENCY.

to have come out of the tragic event that was World War II, it was the renewed resilience of the American people. Fueled by returning GIs, the building boom of the late 1940s witnessed many New Albany families scurrying to the outskirts of town to build their dream homes, at the same time, greatly expanding the city limits and laying the foundations for the growth of the local economy.

Beginning in June 1950, Floyd County sent more young men to the Korean Peninsula when the United States joined the United Nations police action to sanction North Korean troops invading the Republic of South Korea. Eighteen of them gave their lives. The Korean conflict was followed by a lengthy American military involvement in Vietnam in which twelve of Floyd County's own paid the supreme price.

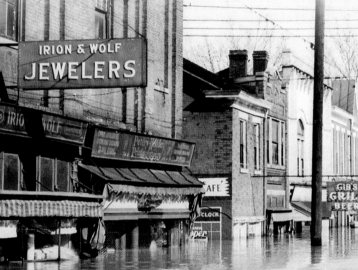

SPRING STREET AT PEARL LOOKING EAST. NOTE THE OPERA HOUSE ON THE LEFT AND THE STEEPLE OF THE FORMER BUILDING OF MARKS CHURCH ON THE RIGHT.

1931 1932 1933 1934 1935

1928
New Albany High School moves into its present building on Vincennes Street on land previously occupied by the old Woolen Mills building, destroyed by the 1917 tornado.

1935
Foster Gunnison, sometimes called "the Henry Ford of Housing," opens the Gunnison Magic Homes Company in New Albany.

THE GREAT FLOOD of 1937

THE FLOOD WATERS CAUGHT THESE AUTOMOBILE OWNERS OFF GUARD AT THE INTERSECTION OF PEARL AND MARKET STREETS IN DOWNTOWN NEW ALBANY. THE F. W. WOOLWORTH CO. 5 & 10 CENT STORE IS ON THE LEFT AND ANOTHER FIVE AND DIME, THE S. S. KRESGE CO., IS ON THE RIGHT. KRESGE'S DID NOT RETURN TO NEW ALBANY AFTER THE FLOOD UNTIL KMART LOCATED ON GRANT LINE ROAD IN THE EARLY 1980s. IN 1977, THE KRESGE COMPANY WAS RENAMED THE KMART CORPORATION.

TIME LINE

1936	1937	1938	1939	1940

1937
The Great Flood inflicts nearly four billion dollars (in present-day money) in damages to New Albany and its residents.

1937
The Firestone Service Station was constructed on the southwest corner of State and Market Streets after the Flood of 1937.

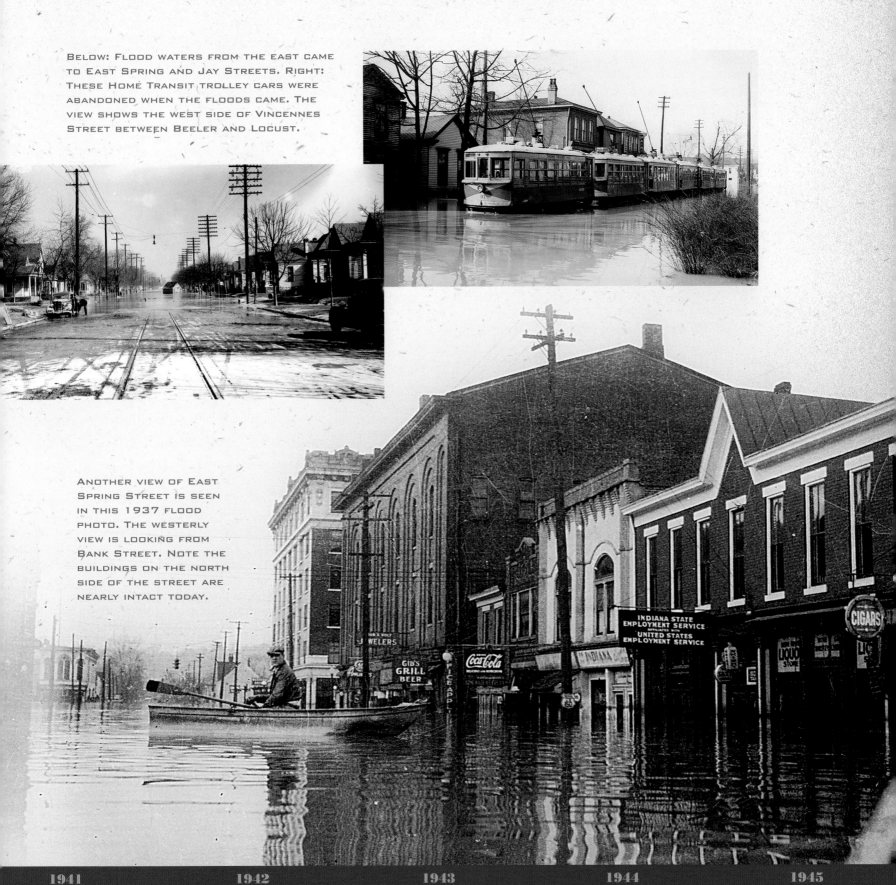

BELOW: FLOOD WATERS FROM THE EAST CAME TO EAST SPRING AND JAY STREETS. RIGHT: THESE HOME TRANSIT TROLLEY CARS WERE ABANDONED WHEN THE FLOODS CAME. THE VIEW SHOWS THE WEST SIDE OF VINCENNES STREET BETWEEN BEELER AND LOCUST.

ANOTHER VIEW OF EAST SPRING STREET IS SEEN IN THIS 1937 FLOOD PHOTO. THE WESTERLY VIEW IS LOOKING FROM BANK STREET. NOTE THE BUILDINGS ON THE NORTH SIDE OF THE STREET ARE NEARLY INTACT TODAY.

1941 1942 1943 1944 1945

1940
Patti Woodard, who spent her childhood years in New Albany, wins the Academy Award for her portrayal of "Ma" Joad in "The Grapes of Wrath."

1941–1945
World War II claims the lives of 114 Floyd Countians.

The middle-to-late twentieth century brought with it a new perception among the citizenry and city leaders of New Albany. In 1963, the sesquicentennial was observed. About the same time, Historic New Albany, Inc., was organized and, with heavy public involvement, helped save the magnificent Culbertson Mansion from the wrecking ball. Concerned that many downtown homes and business establishments had fallen victim to various natural disasters, to the reconfiguration of the Ohio River waterfront following the 1937 flood, and, in many cases, to simply a lack of interest, New Albanians resolved to support a vigorous and far-reaching program of heritage awareness. Not only would the city's history be documented and made more available to the public, but also measures would be implemented to curtail the destruction of historic sites and to preserve and restore those that had been compromised by hard times. The non-profit, volunteer-driven Develop New Albany Organization was founded in 1989 with the goal of economically revitalizing, preserving, and promoting the downtown area by "adhering to the tenants of the National and Indiana Main Street models which focus on the areas of economic restructuring, design, promotion, and organization."

RIGHT: THE CULBERTSON MANSION WAS BUILT AT A COST OF APPROXIMATELY $120,000 IN 1869 FOR WILLIAM S. CULBERTSON. THE MANSION WAS RESCUED FROM THE WRECKING BALL IN 1964 WHEN HISTORIC NEW ALBANY, INC. PURCHASED THE HOME. IN 1976, THE STATE OF INDIANA ACCEPTED THIS IMPORTANT STRUCTURE TO BE MAINTAINED AS A STATE HISTORIC SITE.

TIME LINE

1946 1948 1950 1952 1954

1949
Former Indiana U.S. senator and New Albany High School graduate Sherman Minton is appointed associate justice of the United States Supreme Court by President Harry S. Truman.

1950–1953
The Korean conflict takes the lives of eighteen more Floyd Countians.

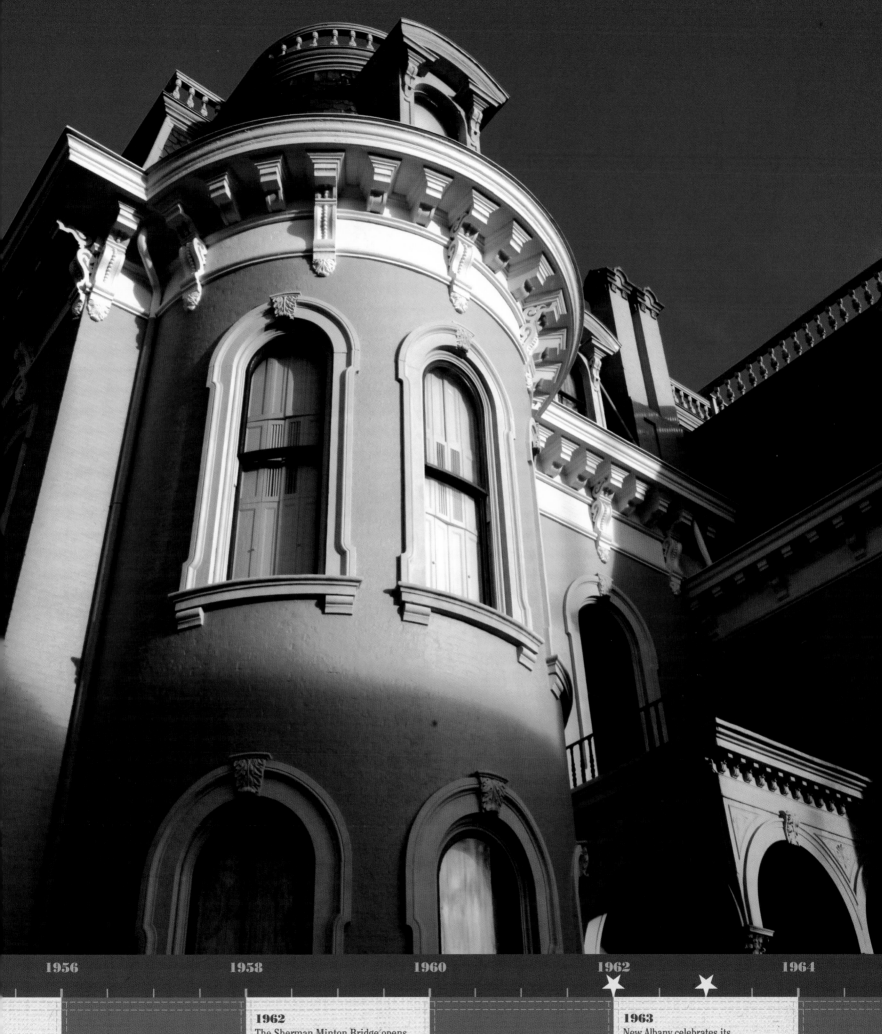

1956 1958 1960 1962 1964

1962
The Sherman Minton Bridge opens across the Ohio River at a cost of $14.8 million.

1963
New Albany celebrates its Sesquicentennial. Historic New Albany, Inc., is organized and eventually saves the Culbertson Mansion from the wrecking ball in 1964.

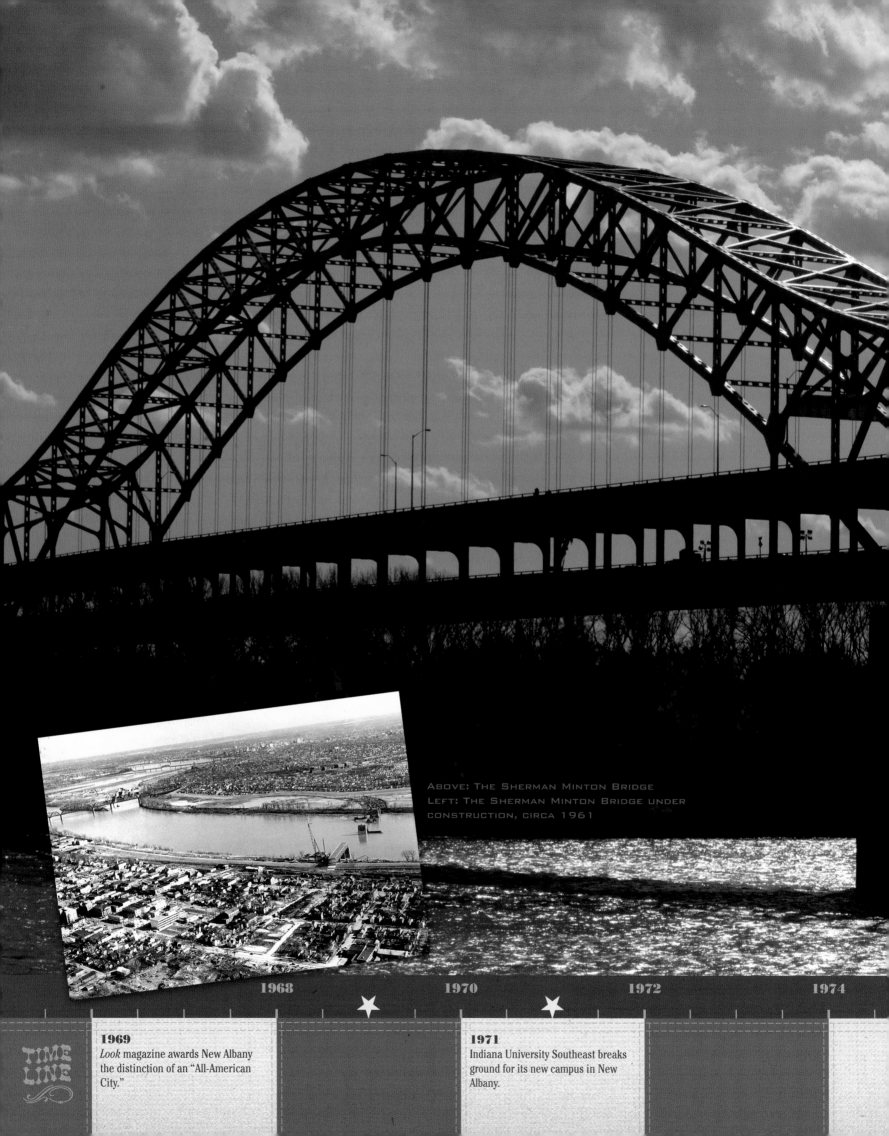

ABOVE: THE SHERMAN MINTON BRIDGE
LEFT: THE SHERMAN MINTON BRIDGE UNDER
CONSTRUCTION, CIRCA 1961

1968 1970 1972 1974

TIME
LINE

1969
Look magazine awards New Albany
the distinction of an "All-American
City."

1971
Indiana University Southeast breaks
ground for its new campus in New
Albany.

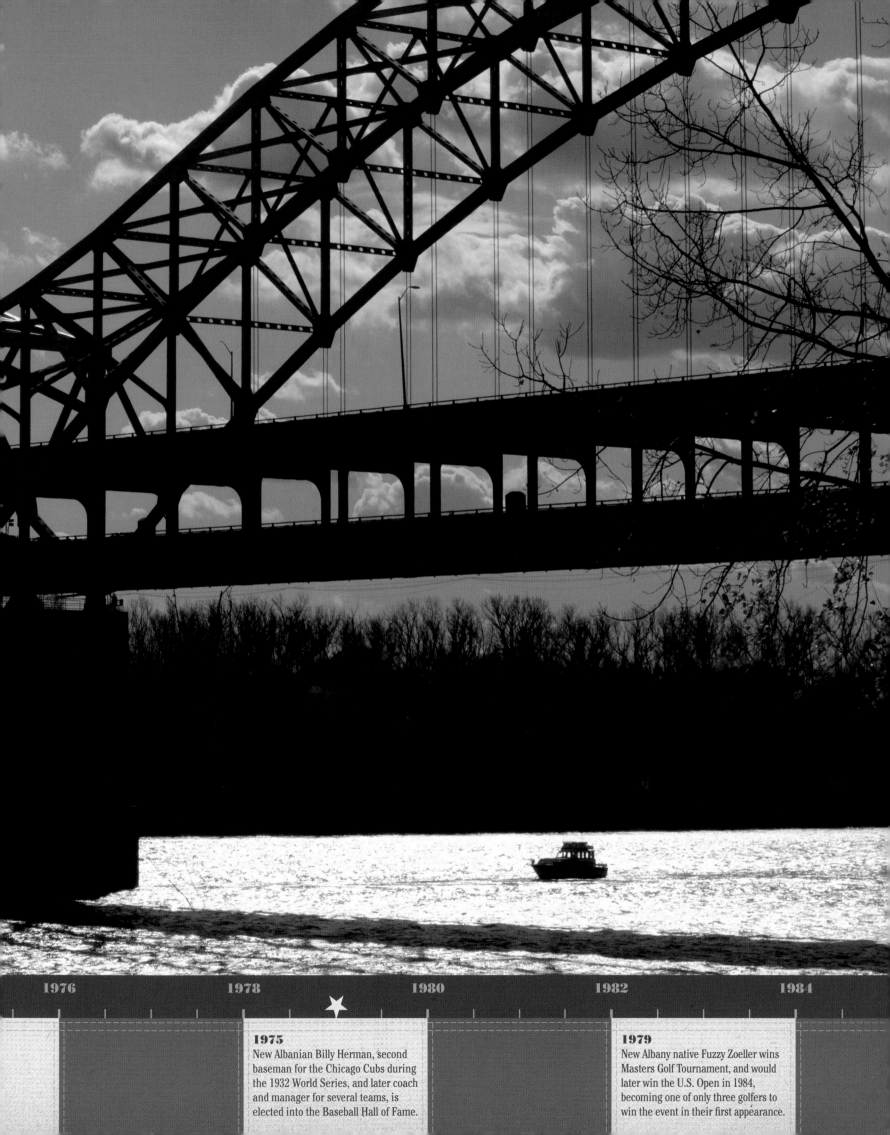

1975
New Albanian Billy Herman, second baseman for the Chicago Cubs during the 1932 World Series, and later coach and manager for several teams, is elected into the Baseball Hall of Fame.

1979
New Albany native Fuzzy Zoeller wins Masters Golf Tournament, and would later win the U.S. Open in 1984, becoming one of only three golfers to win the event in their first appearance.

LEFT: FORMER NEW ALBANY MAYOR DOUGLAS ENGLAND, DIVISION STREET SCHOOL BOARD MEMBER VICTOR MEGENITY, AND GARY LEAVELL ACCEPT THE HISTORIC WINDOW SHADE THAT RECORDED GENERATIONS OF BURIALS IN NEW ALBANY'S AFRICAN-AMERICAN, WEST HAVEN CEMETERY. BELOW: "RESARTUS," BY LOCAL SCULPTOR DOMINIC GUARNASCHELLI, INSTALLED ON THE FRONT LAWN OF CARNEGIE CENTER FOR ART & HISTORY, IS PART OF THE NEW ALBANY BICENTENNIAL PUBLIC ART PROJECT, A MULTI-YEAR OUTDOOR EXHIBITION OF TEMPORARY ART INSTALLATIONS THAT INTERPRET NEW ALBANY'S RICH HISTORY AND HERITAGE THROUGH THE EYES OF ARTISTS.

Today, the Floyd County Historical Society, operating its museum in the historic William Young House on West Market Street, along with other institutions in the city—the Carnegie Center for Art and History, the Culbertson Mansion, the Scribner House, and the Division Street School—all tell the interesting story of New Albany's rich and varied past from prehistoric times to recent days. In 2009, city leaders led by Mayor Doug England approved the formation of a Bicentennial Commission that was charged with preparing the city and its residents for the long-anticipated two-hundredth anniversary of the founding of New Albany by the Scribner brothers. An ambitious Public Art

TIME LINE

1989
The Develop New Albany Organization, a non-profit, volunteer-driven group is founded with the mission to revitalize, preserve, and promote downtown New Albany.

1990
NASA launches the Hubble Space Telescope, named in honor of one-time New Albany High School teacher and basketball coach Edwin Hubble, father of the theory of an expanding universe.

200 YEARS

Project, which depicts major milestones in the town's development and history, has erected exhibits throughout the town regarding early settlement and agriculture, as well as the glass, textile, media, and hospitality industries.

As New Albanians look back on the past two hundred years, they gaze forward to the future with a sense of immense satisfaction and anticipation. Ever mindful of their history and heritage, they are proud of the achievements and legacies left to them by their ancestors and are intent on providing their descendants with the same core values and quality of life. Surrounded by several colleges, universities, and numerous religious institutions, New Albany is the epitome of all that is good about America. Some of the most beautiful and bountiful land in the United States is just a stone's throw away, along with one of the three largest and busiest river

systems in the nation. New Albany sits astride the intersection of two of the country's most-traveled interstate highway systems, I-64 and I-65, placing the city at a critical crossroads, mid-way north and south between Chicago and Mobile, and east and west between the Atlantic Ocean and St. Louis. With a population of less than forty thousand—small enough for intimacy and quality of life—yet part of the Louisville Metropolitan area with a population of around one and one-half million, New Albany is truly an All-American city, a real jewel on the Ohio.

Present-day New Albanians share the values that the Scribner brothers brought with them to the Falls of the Ohio two hundred years ago—ambition, independence, down-home honesty, religion, and education. They will ensure that the next two centuries provide for their progeny all of these ideals that have guided them since 1813.

NEW ALBANY INDIANA
BICENTENNIAL
1813 - 2013
By the River's Edge

2001 2004 2007 2010 2013

2009
Mayor Doug England approves the formation of a Bicentennial Commission, charged with planning the celebration of the two-hundredth anniversary of New Albany.

2013
The City of New Albany celebrates its 200th anniversary.

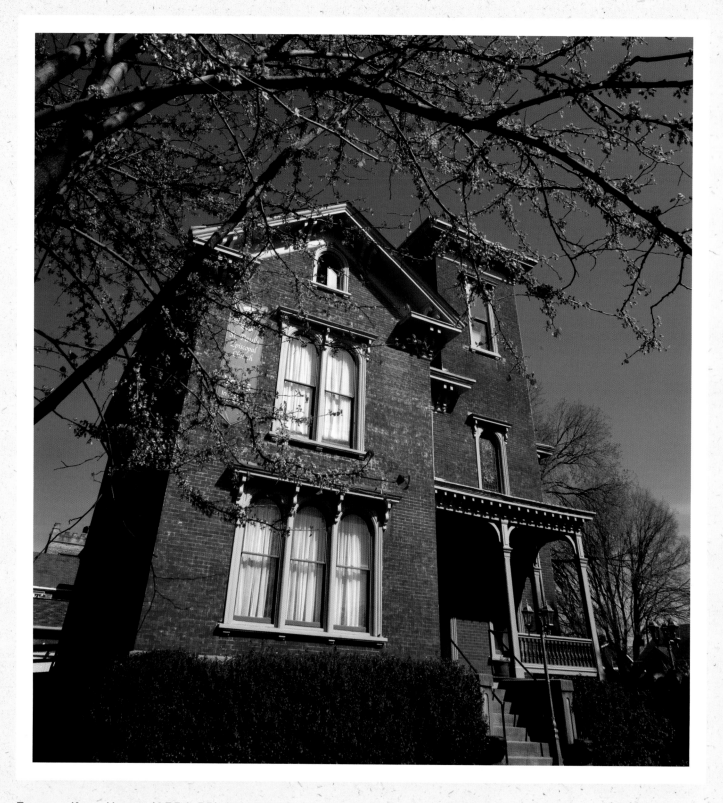

Phineas Kent House (1854–55), 1015 East Main Street. This Italianate Tuscan Villa is now the parish house of St. Paul's Episcopal Church.

Previous spread: YMCA of Southern Indiana, Floyd County Branch
Right: St. Mary of the Annunciation Roman Catholic Church (1858), 719 East Spring Street, listed in the East Spring Street National Register Historic District.

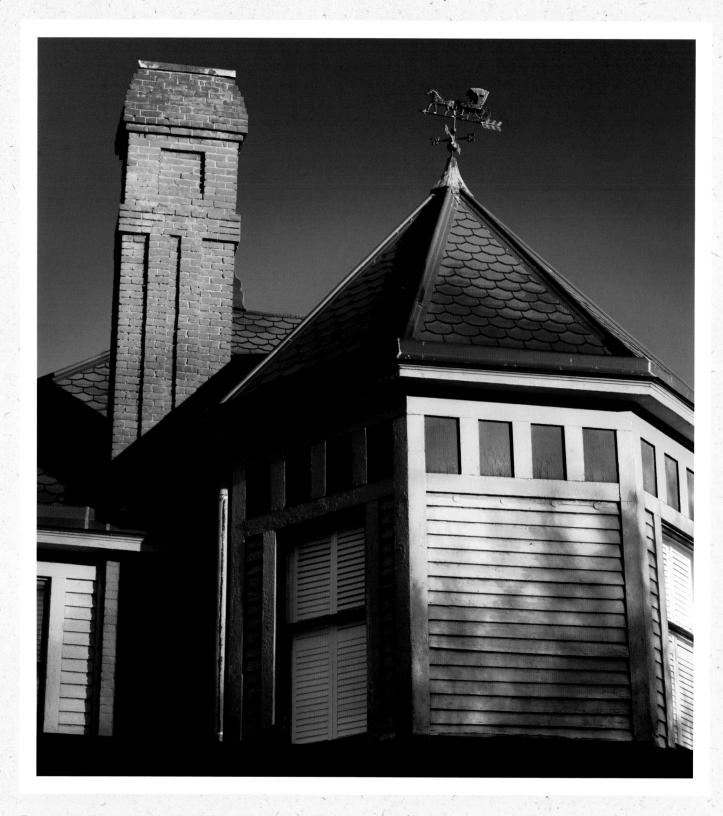

George H. Devol House (1889), 601 East Main Street weathervane

Previous spread: St. John United Presbyterian Church (1890), originally built for the Second
Presbyterian Congregation, 1307 East Elm Street
Right: Spring at the Blessing-Malbon House (1848), 907 East Main Street

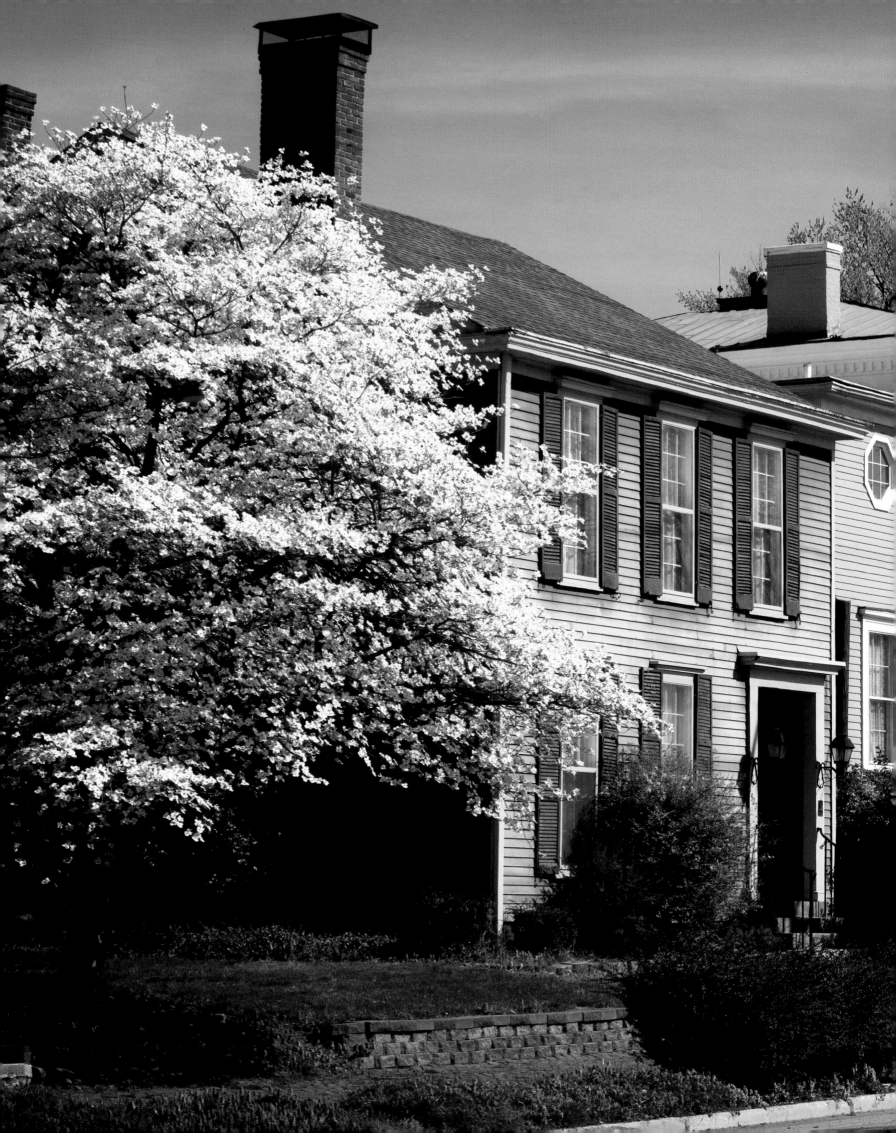

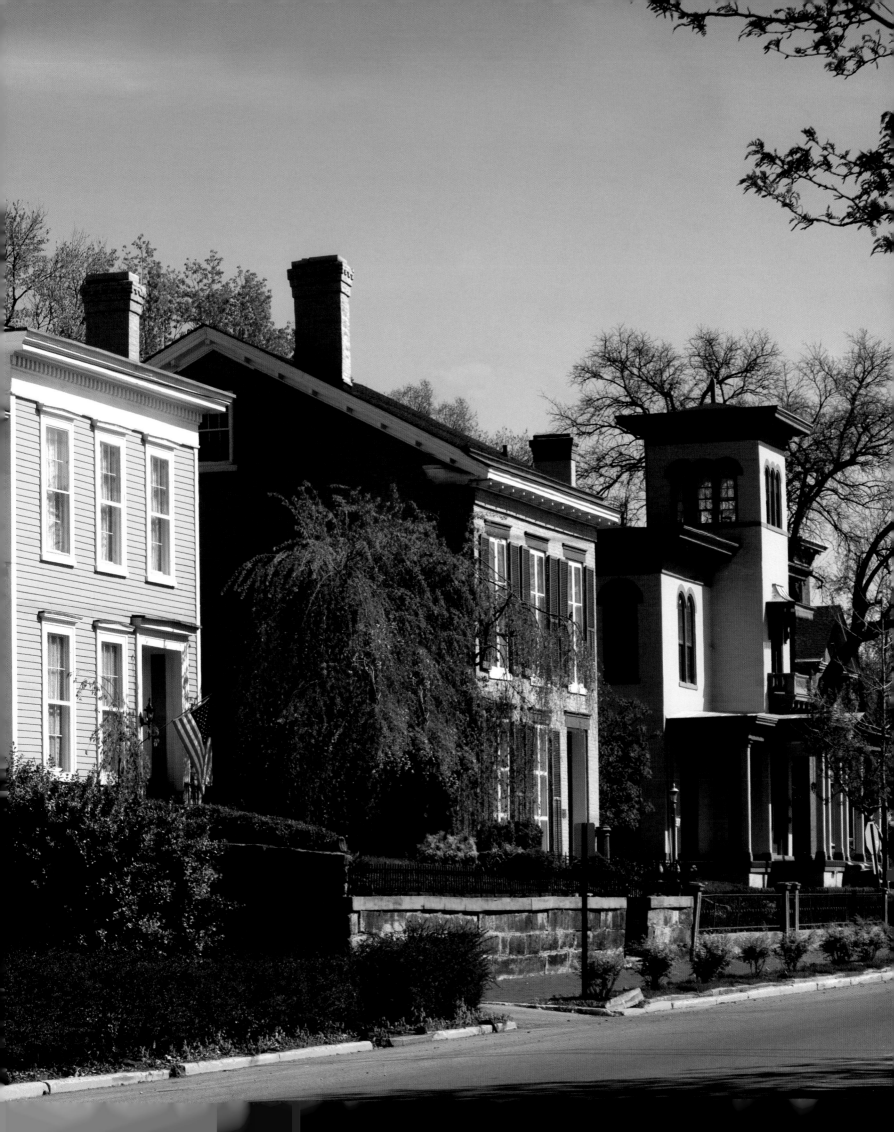

VICTORIAN PORCH ON THE NEWBURGER-LIND HOUSE (1900), 616 EAST MAIN STREET

PREVIOUS SPREAD: NEW ALBANY'S MANSION ROW NATIONAL REGISTER HISTORIC DISTRICT, EAST MAIN STREET
LEFT: NATIONAL REGISTER HISTORIC DISTRICT OF DEPAUW AVENUE FROM VANCE AVENUE

Indiana University Southeast

Previous spread: McCullough Plaza at Indiana University Southeast campus, Grant Line Road

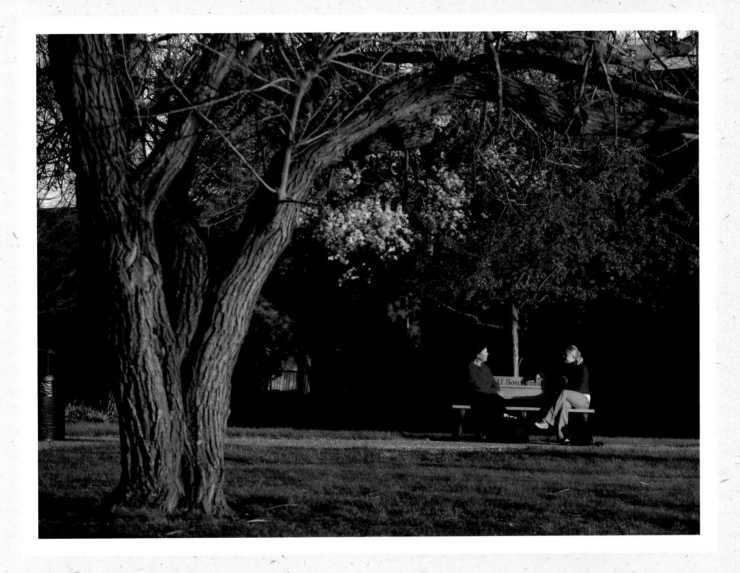

Indiana University Southeast

Following spread: Sherman Minton Bridge from the Scribner House

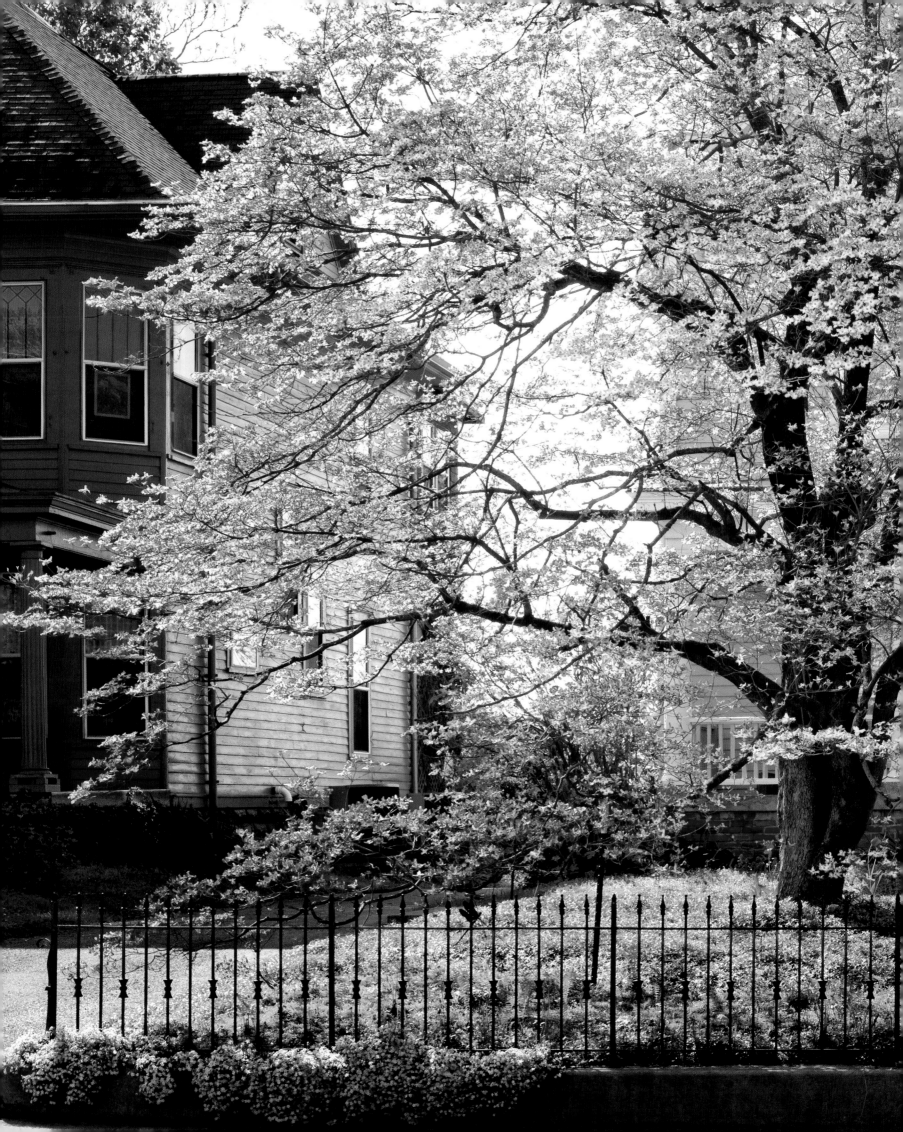

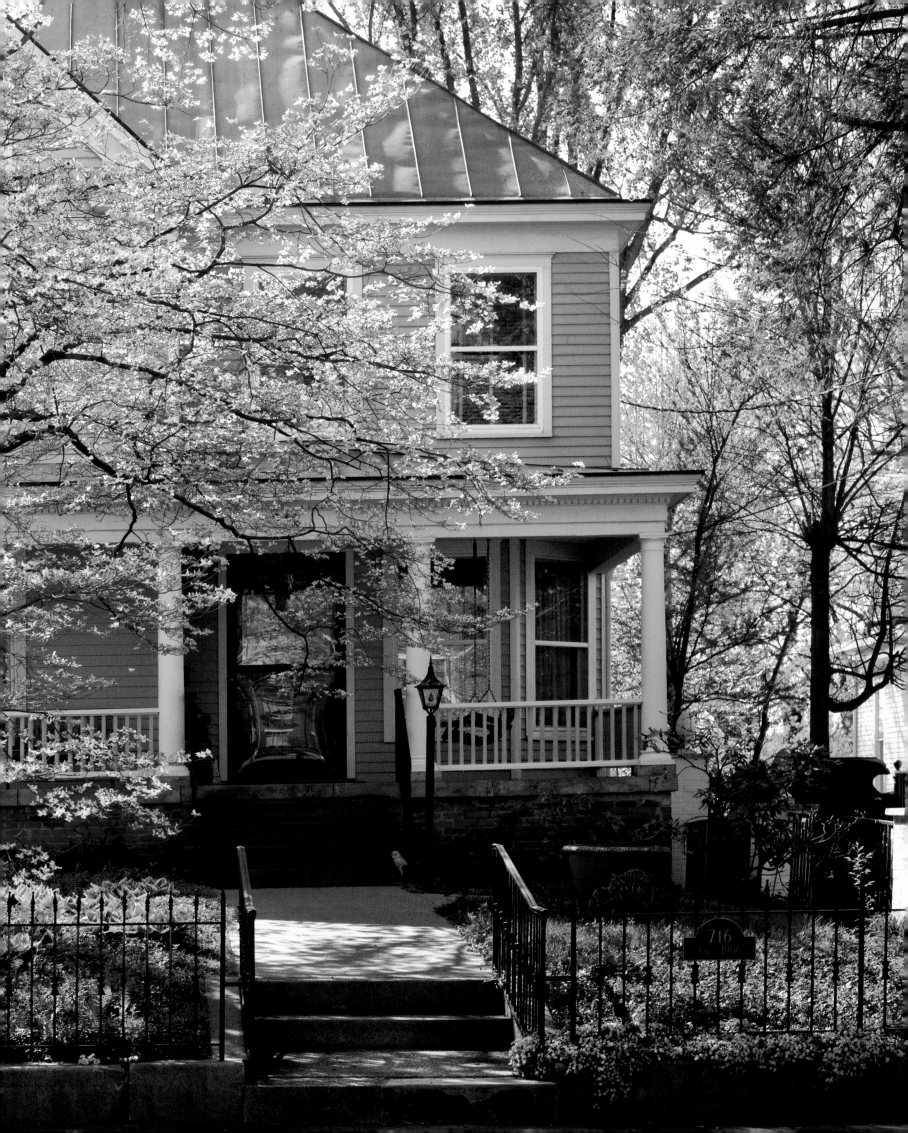

CRUMBO-HUNTER HOUSE (CA.1922), 2011 DEPAUW AVENUE

PREVIOUS SPREAD: CONNER-HEGEWALD HOUSE (1906), 716 EAST MAIN STREET. THE STATE ARBORIST HAS DETERMINED THAT THE DOGWOOD TREE AT THIS RESIDENCE IS INDIANA'S OLDEST.

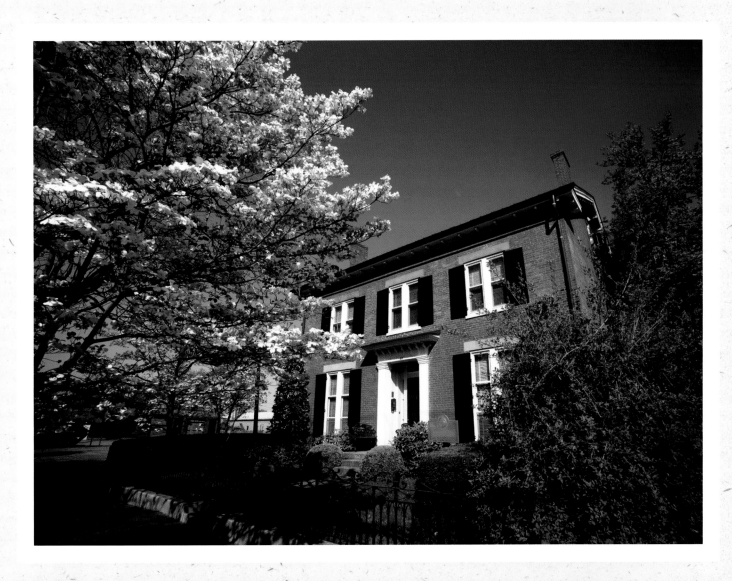

Isaac P. Smith House (1848–53) Federal/Greek Revival residence at 513 East Main Street

1809 DePauw Avenue, the John A. Gadient House (ca.1930)

MATTHIAS DOWERMAN HOUSE (CA. LATE 1830S), 1738 STATE ROAD 111 SOUTH

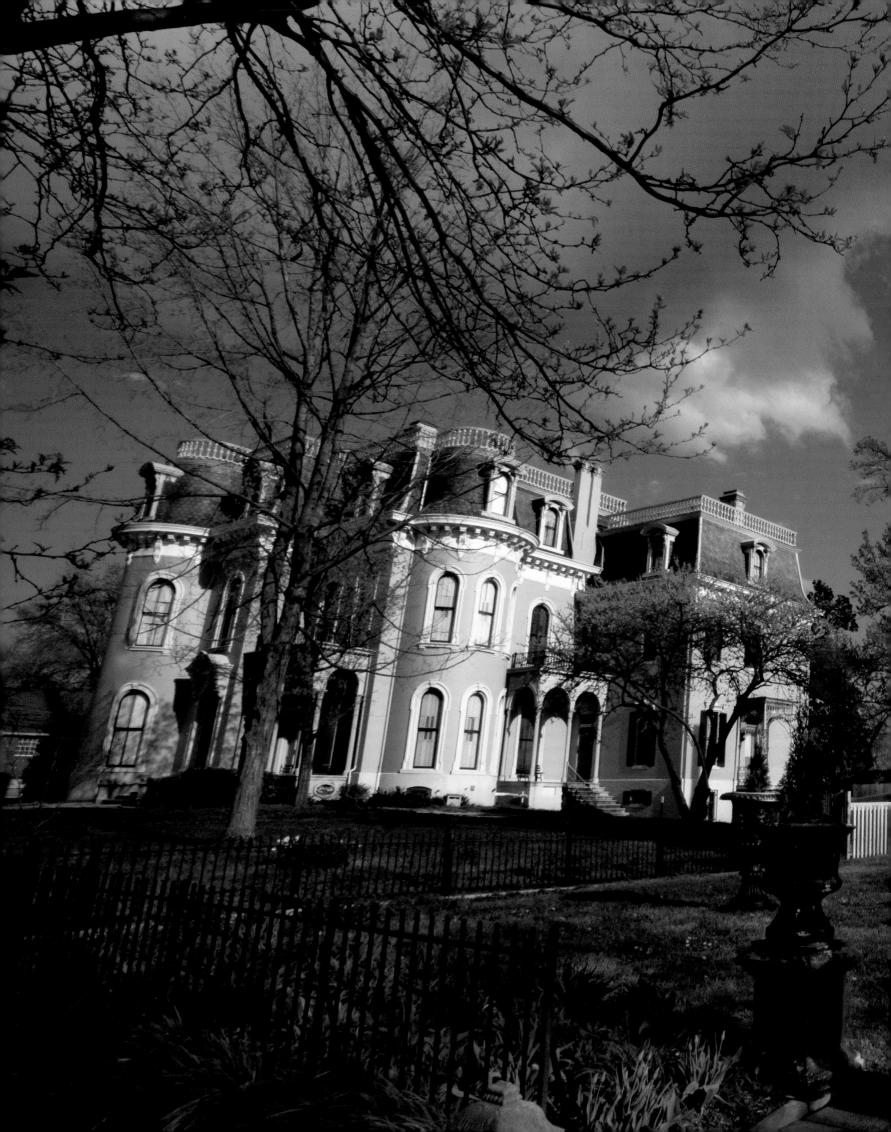

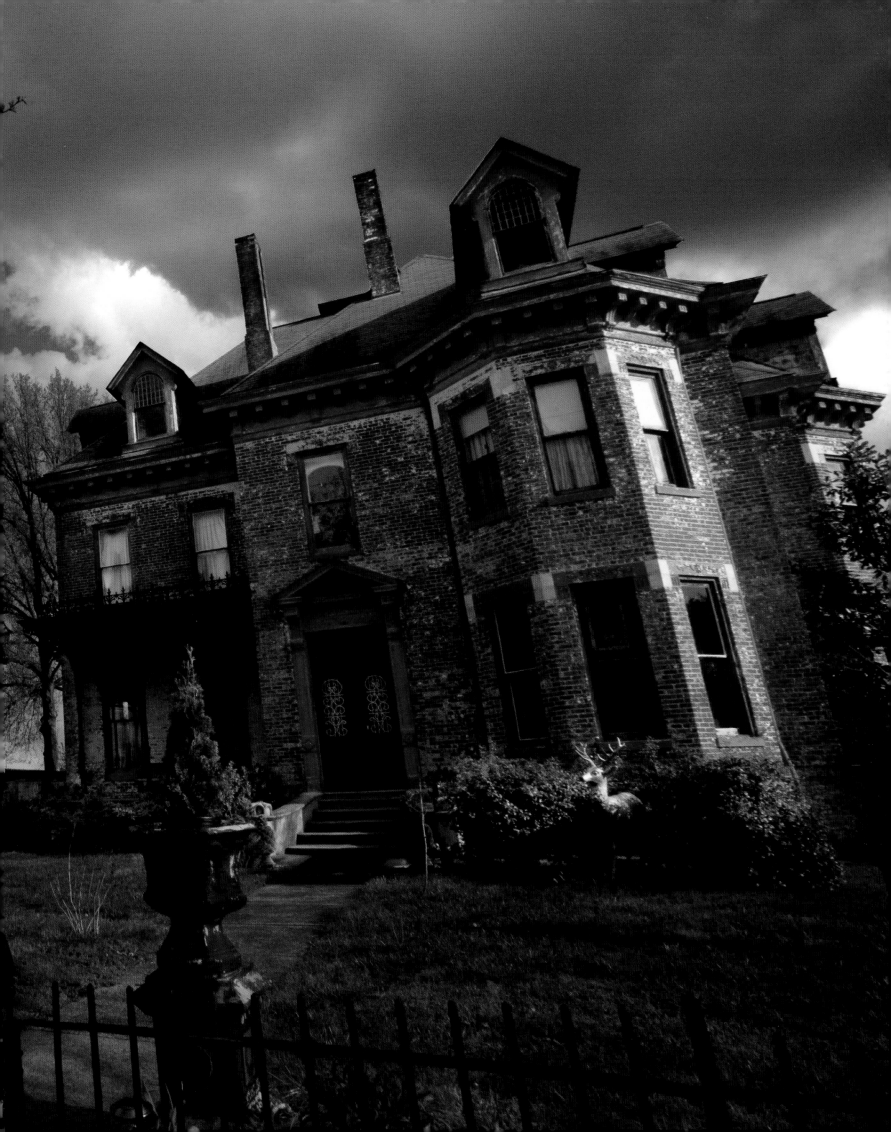

Merchants National Bank Building (1869), Italianate structure at the northeast corner of Pearl & Main Streets

Previous spread: Culbertson Mansion State Historic Site (1869), 907 East Main Street and the Samuel Culbertson Home (1886), 914 East Main Street

HIEB BUILDING (1870), ITALIANATE STRUCTURE AT 316–318 PEARL STREET

"BREW HISTORY: ALL BOTTLED UP," A NEW ALBANY BICENTENNIAL PUBLIC ART PROJECT BY LETICIA BAJUYO THAT WAS LOCATED AT THE NEW ALBANIAN BANK STREET BREWHOUSE AT 415 BANK STREET

PREVIOUS SPREAD: "TOOLS OF THE TRADE: FIBER ART BY BETTE LEVY," CARNEGIE CENTER FOR ART & HISTORY, 201 EAST SPRING STREET

"Nature's Calligraphy," a New Albany Bicentennial Public Art Project by Janis Martin, Ruth Andrews, and Michael Slaski, and located at Farmers Market, 202 East Market Street

Brad White's "Scars into Stars" sculpture is a Historic Theme: Underground Railroad interpretation for the New Albany Bicentennial Public Art Project and was located at 129 West Main Street.

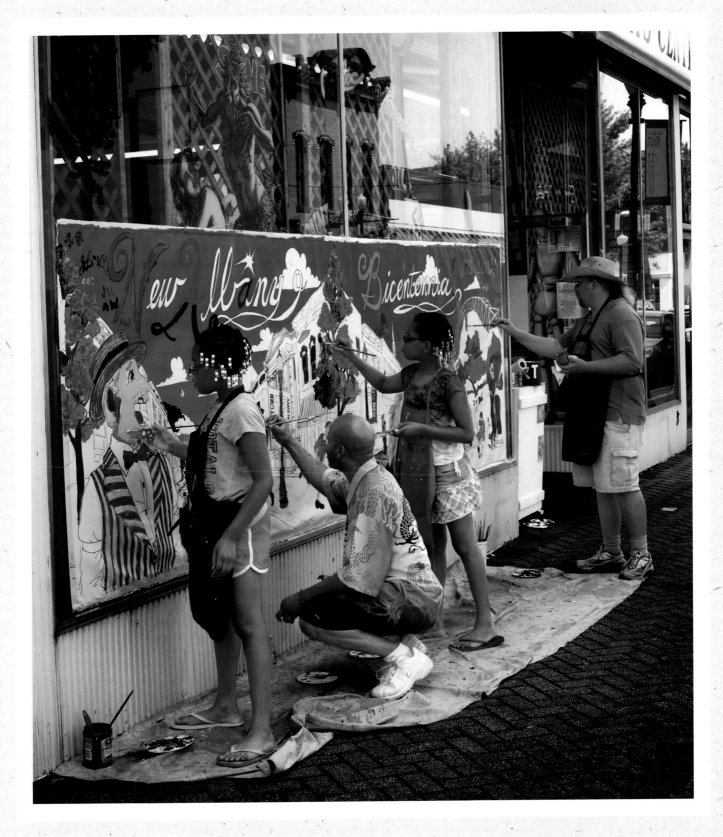

CITIZENS JOIN TO PAINT A MURAL COMMEMORATING NEW ALBANY'S BICENTENNIAL ON PEARL STREET.

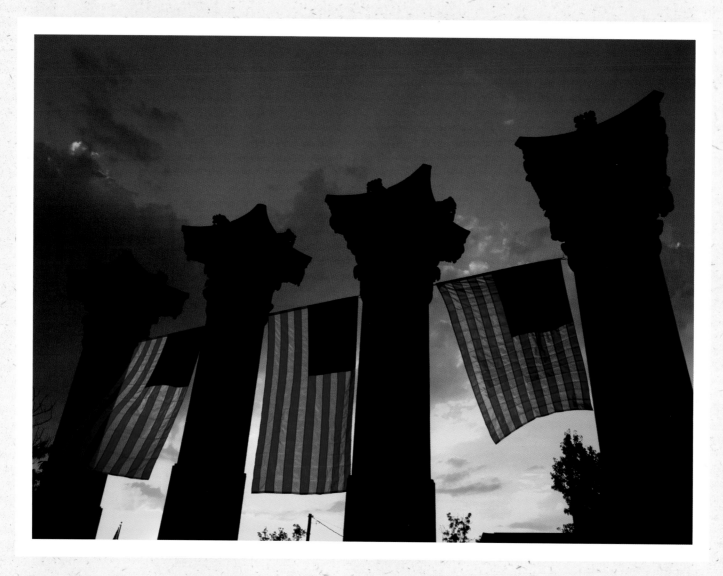

Bicentennial display of historic American flags, southwest corner of Hauss Square and West Spring Street

Right: Fourth of July fireworks display at the Riverfront Heritage Overlook Amphitheatre

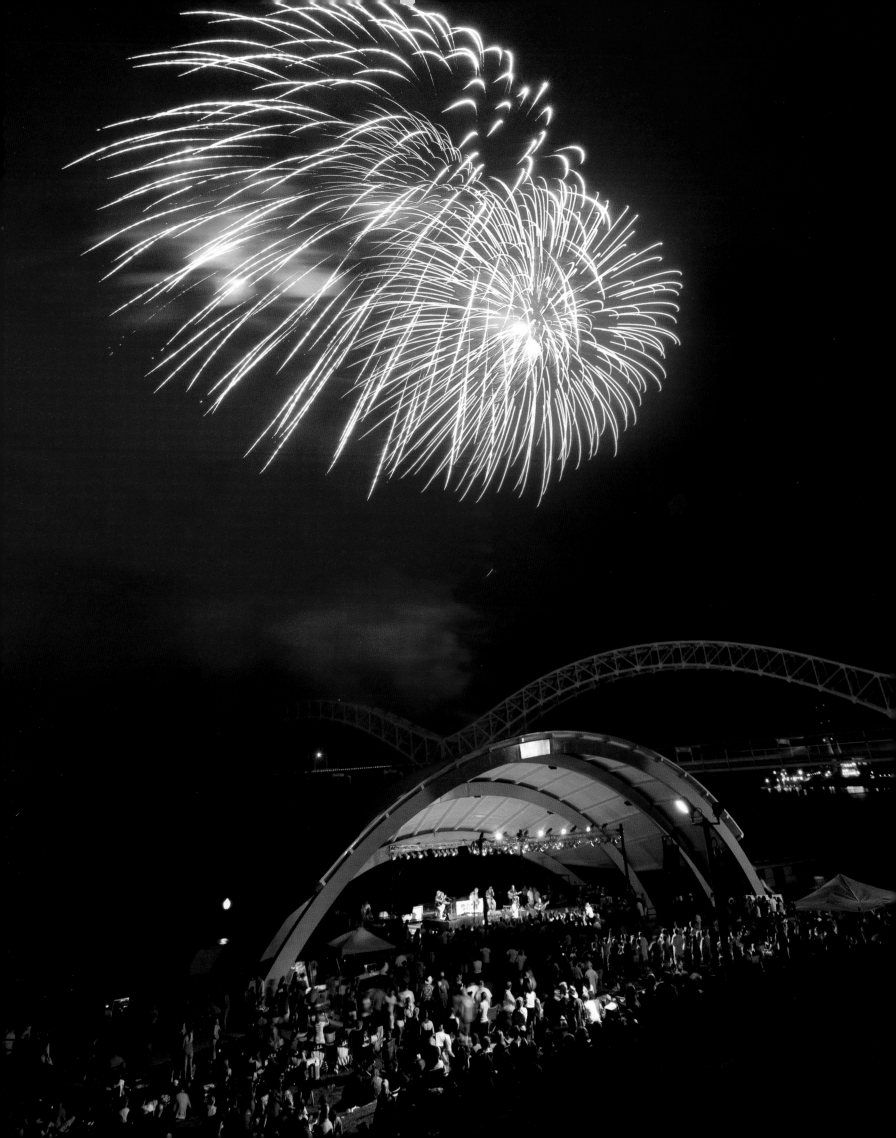

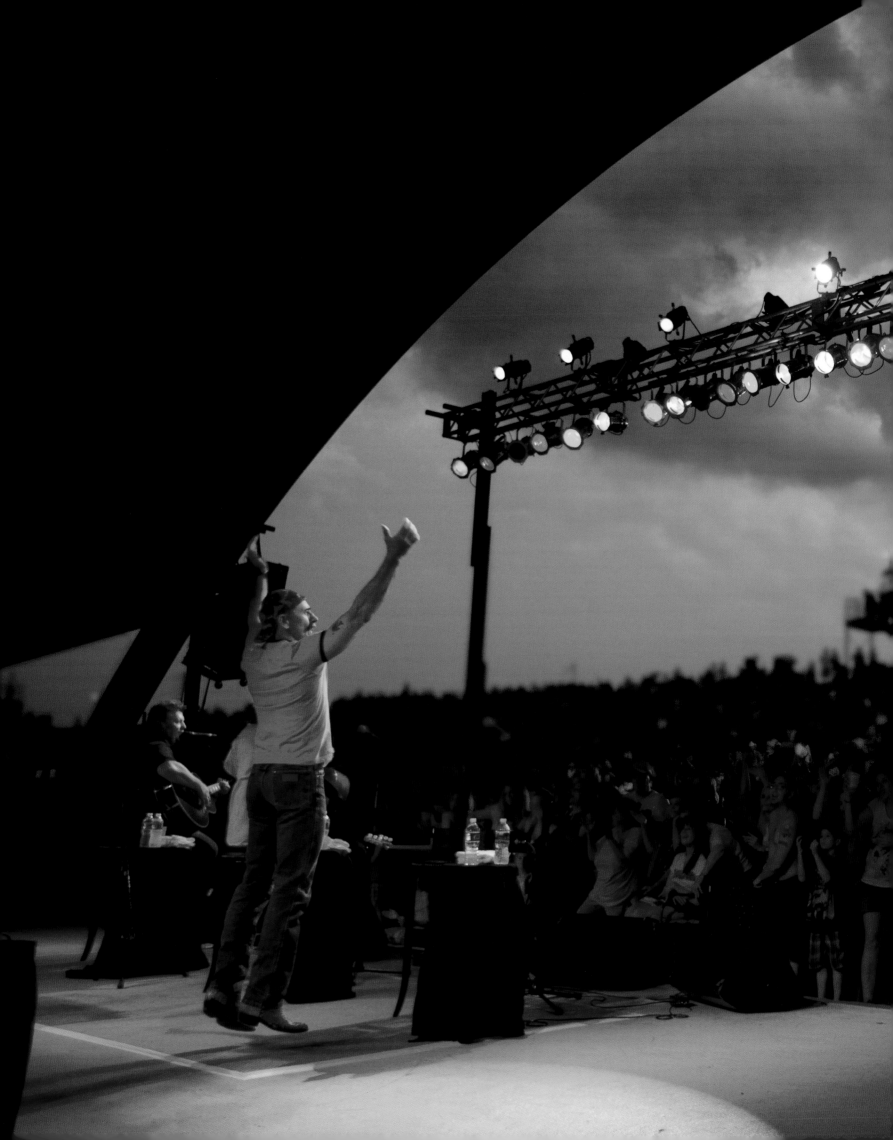

NEW ALBANY NATIONAL CEMETERY, A NATIONAL REGISTER OF HISTORIC PLACES LISTED PROPERTY, IS LOCATED AT 1943 EKIN AVENUE.

PREVIOUS SPREAD: FOURTH OF JULY CONCERT AT THE RIVERFRONT HERITAGE OVERLOOK AMPHITHEATRE
RIGHT: "RICHARD LORD JONES," SERVED AS A REVOLUTIONARY WAR FIFER AT THE AGE OF TEN, MOVED TO NEW ALBANY LATER IN HIS LIFE, AND IS BURIED IN FAIRVIEW CEMETERY. BICENTENNIAL LIVING HISTORY MEMBERS AT THE SCRIBNER HOUSE PORTRAY THE "YOUNG JONES," AND "OLDER NEW ALBANY CITIZEN JONES."

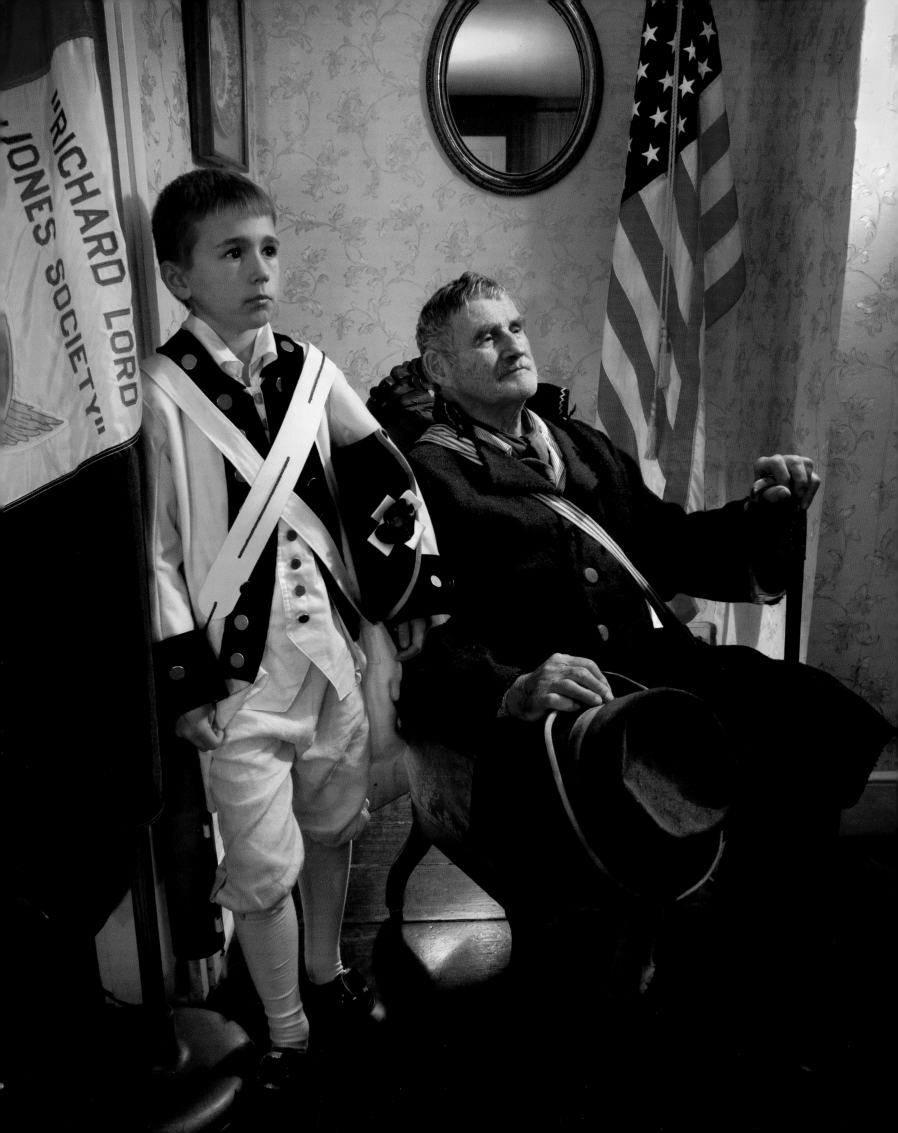

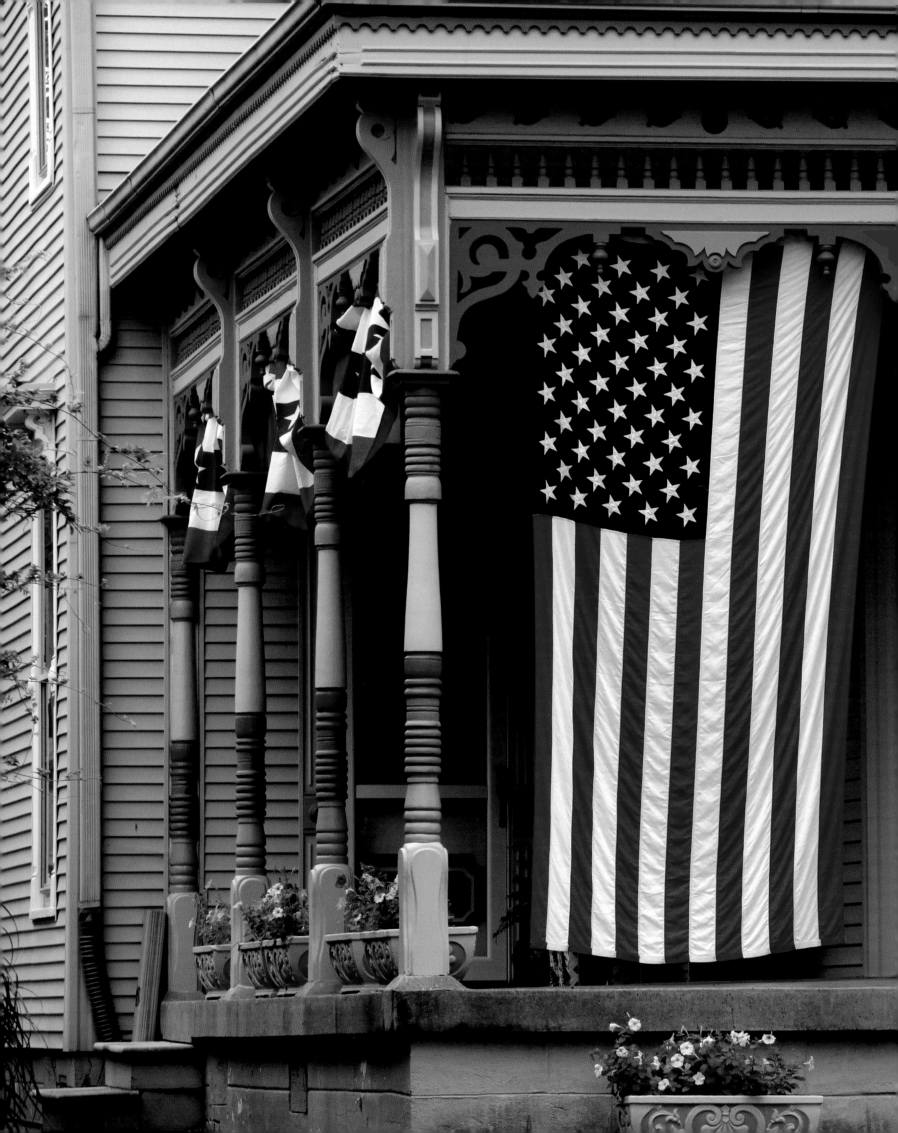

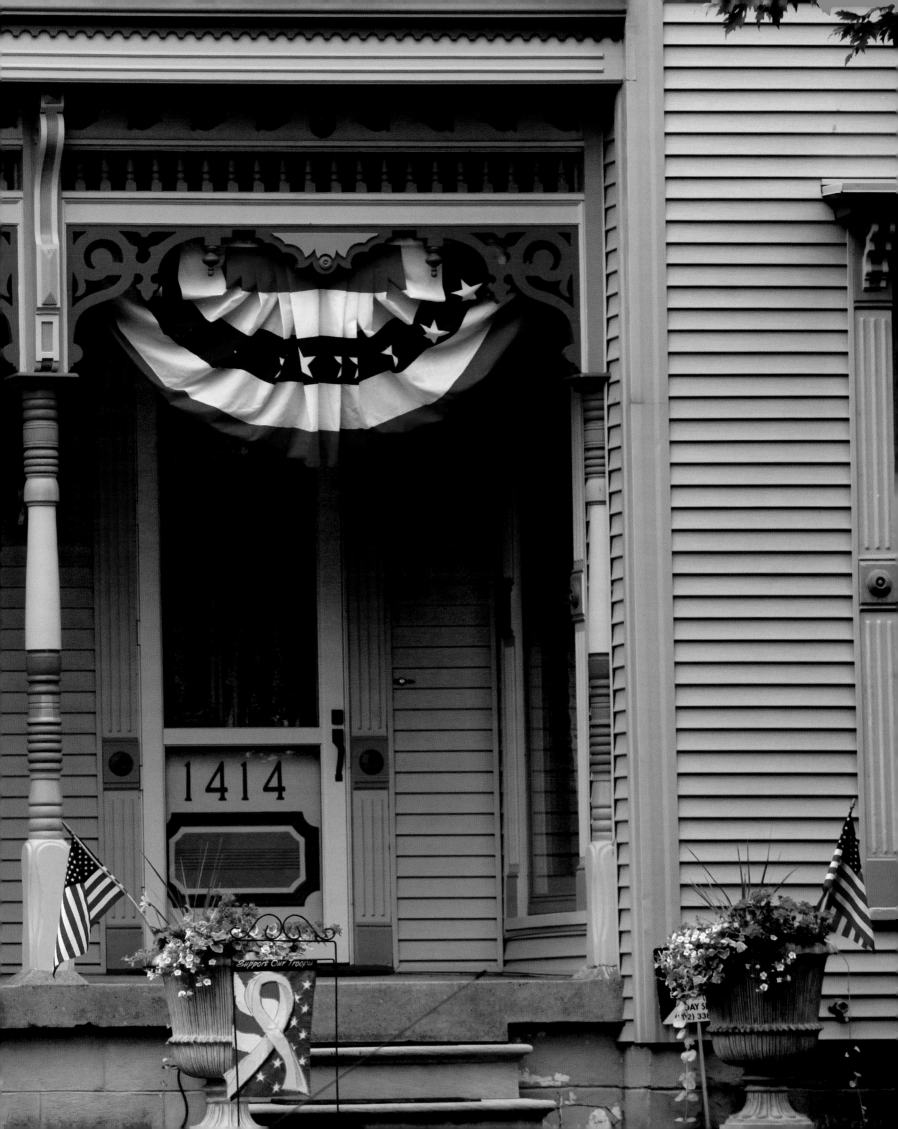

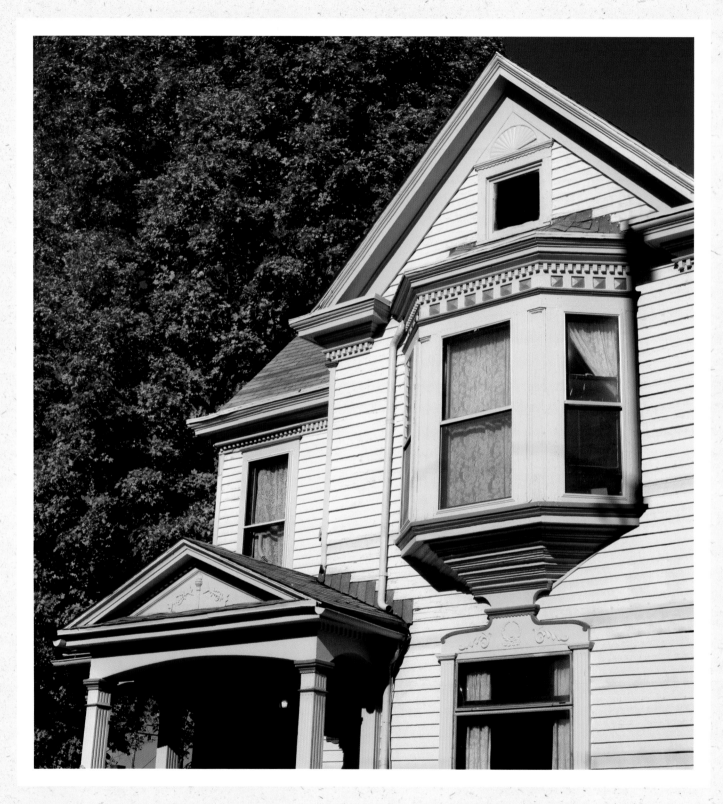

RESIDENCE AT 1401 EAST MAIN STREET, THE HISTORIC EDWARD M. BIR HOUSE (1899)

PREVIOUS SPREAD: FOURTH OF JULY AT 1414 EAST MARKET STREET RESIDENCE, THE HISTORIC GEORGE AND MARY BORGERDING HOUSE (1889)

RIGHT: EUGENE V. KNIGHT HOUSE (1912), AMERICAN FOURSQUARE STRUCTURE AT 1217 EAST MAIN STREET, DECORATED FOR THE FOURTH OF JULY

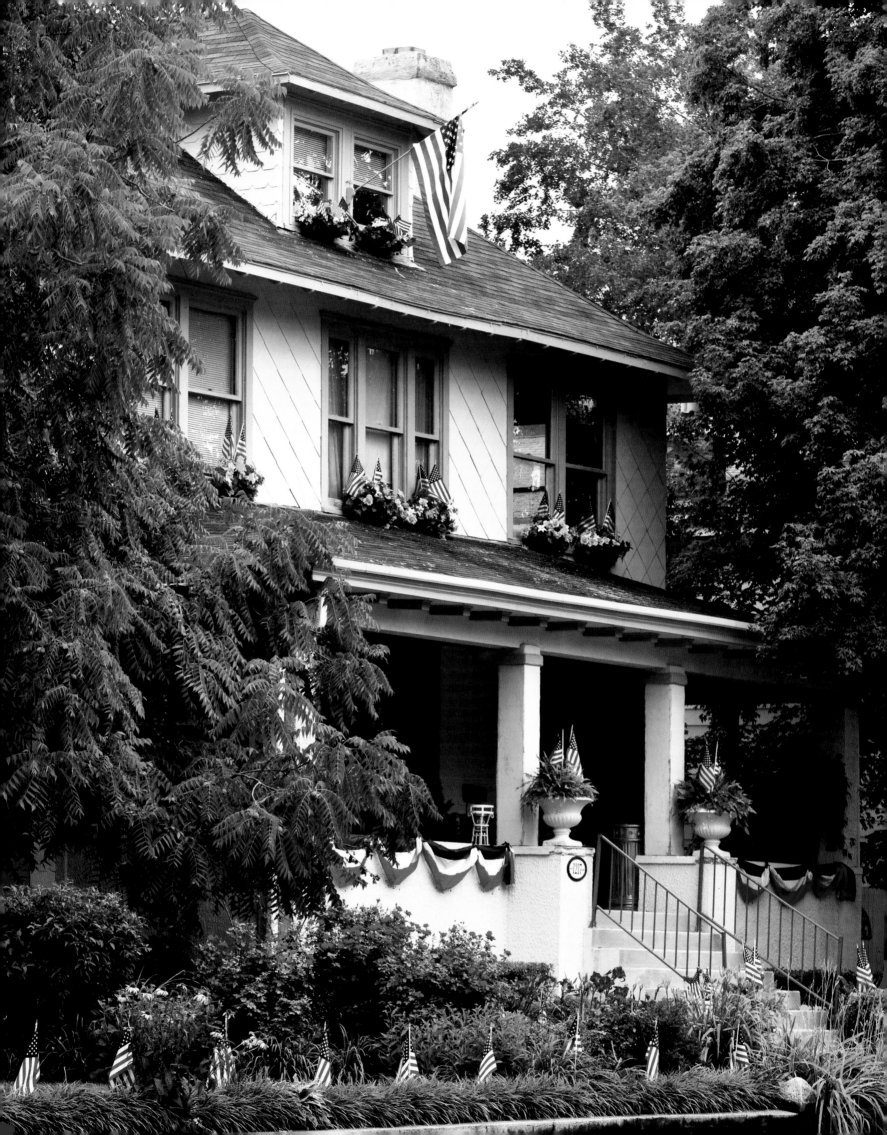

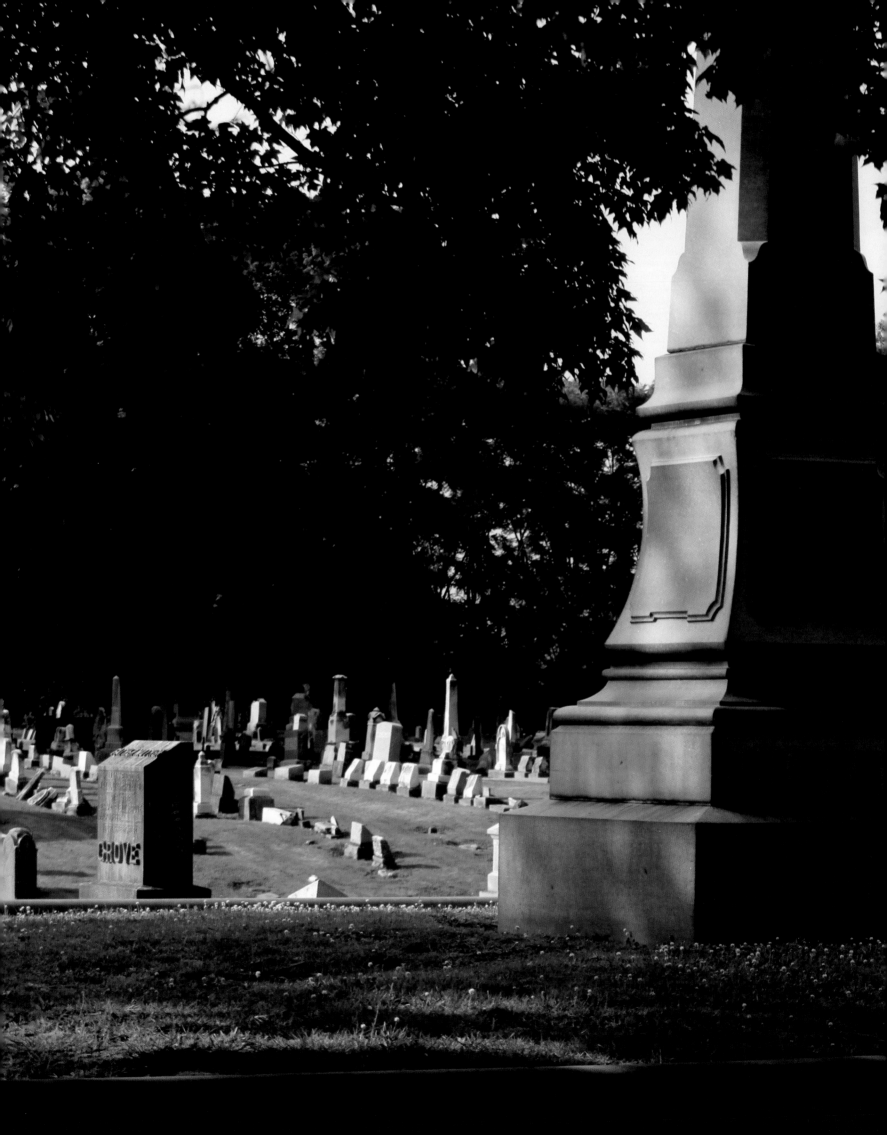

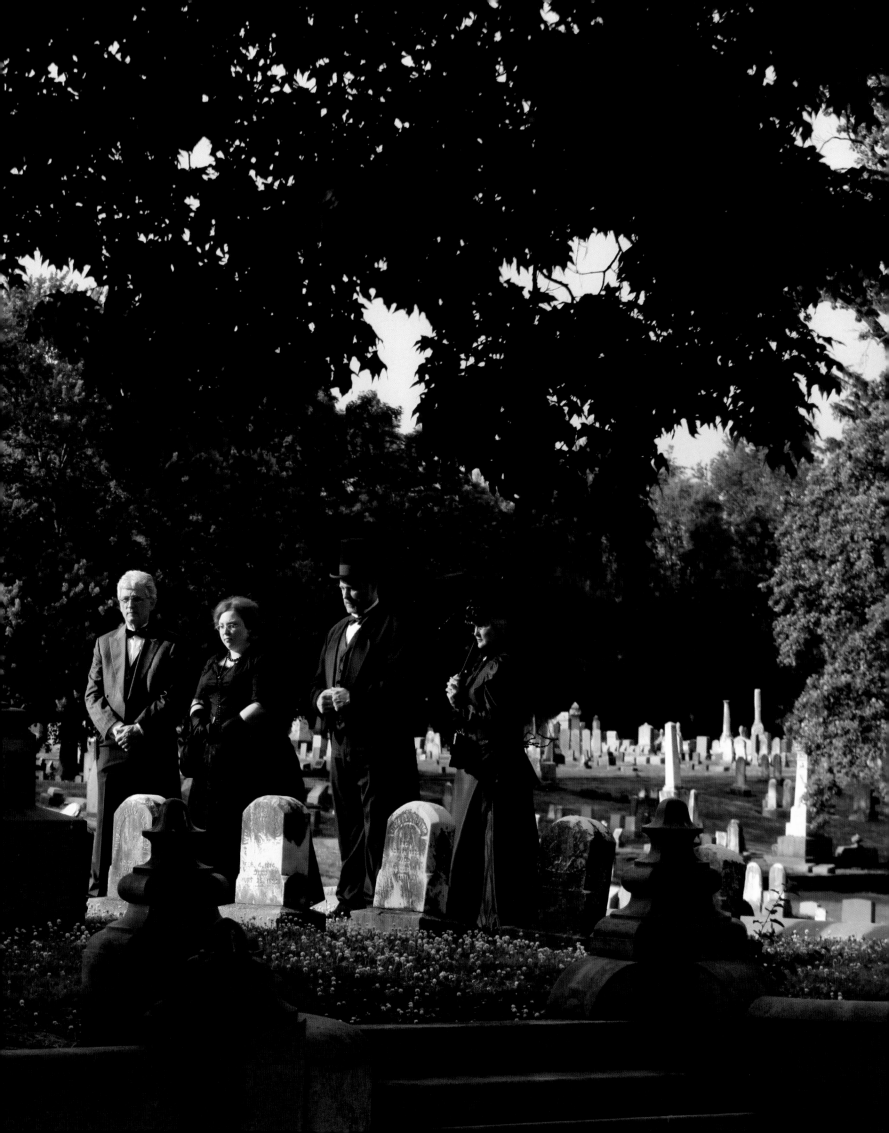

East Spring Street residence decorated for Harvest Homecoming.

Previous spread: Bicentennial Living History Committee members portray Culbertson family mourners "Frank Semple, Louise Culbertson, Samuel Culbertson, and Anne Culbertson Semple" for a "William Culbertson Funeral" reenactment at the Historic Fairview Cemetery.
Right: Conner-Mann House, Italianate home (ca. 1845) built for Conner & Reineking Dry Goods proprietor, William C. Conner

CLASSROOM IN THE HISTORIC AFRICAN-AMERICAN DIVISION STREET SCHOOL (1885), 1803 CONSERVATIVE STREET. THE SCHOOL IS LISTED IN THE NATIONAL REGISTER OF HISTORIC PLACES.

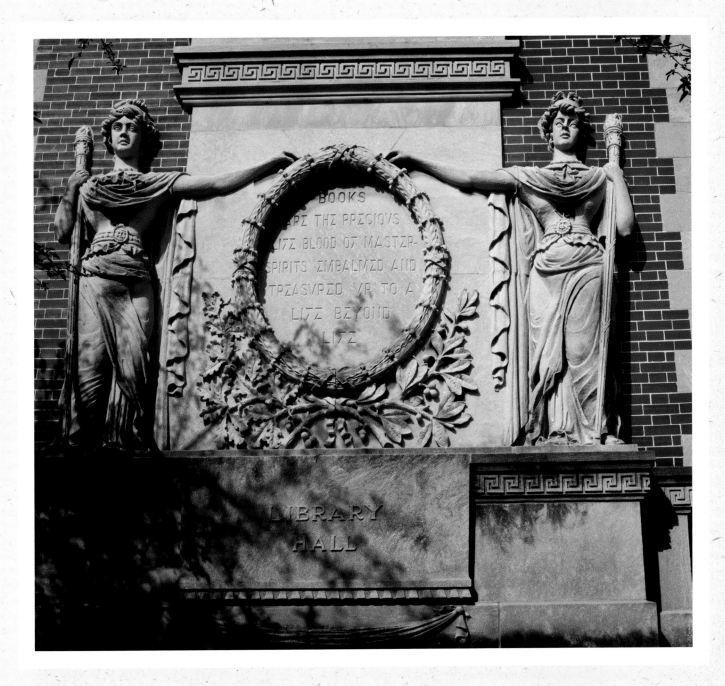

Neoclassical architectural detail of the New Albany Carnegie Public Library (1902–1904), listed in the New Albany Downtown National Register Historic District

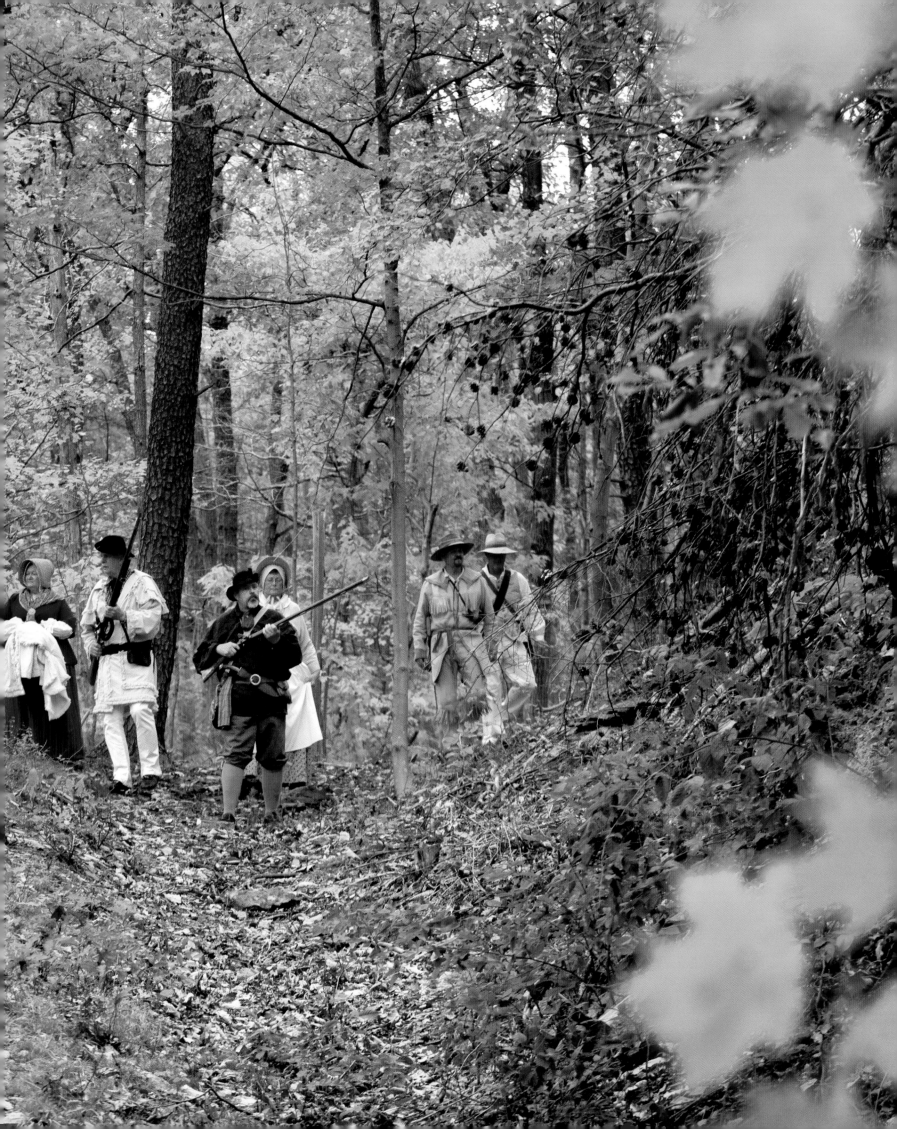

Late 18th-century surveyor's compass

Previous spread: Reenactment of "Pioneers Traveling West along the Floyds Knobs Section of the Buffalo Trace," as presented by the Bicentennial Living History Committee
Right: New Albany surveyors David Ruckman and William Ruckman demonstrate surveying techniques on a section of the Buffalo Trace using original 18th-century surveyor's instruments.

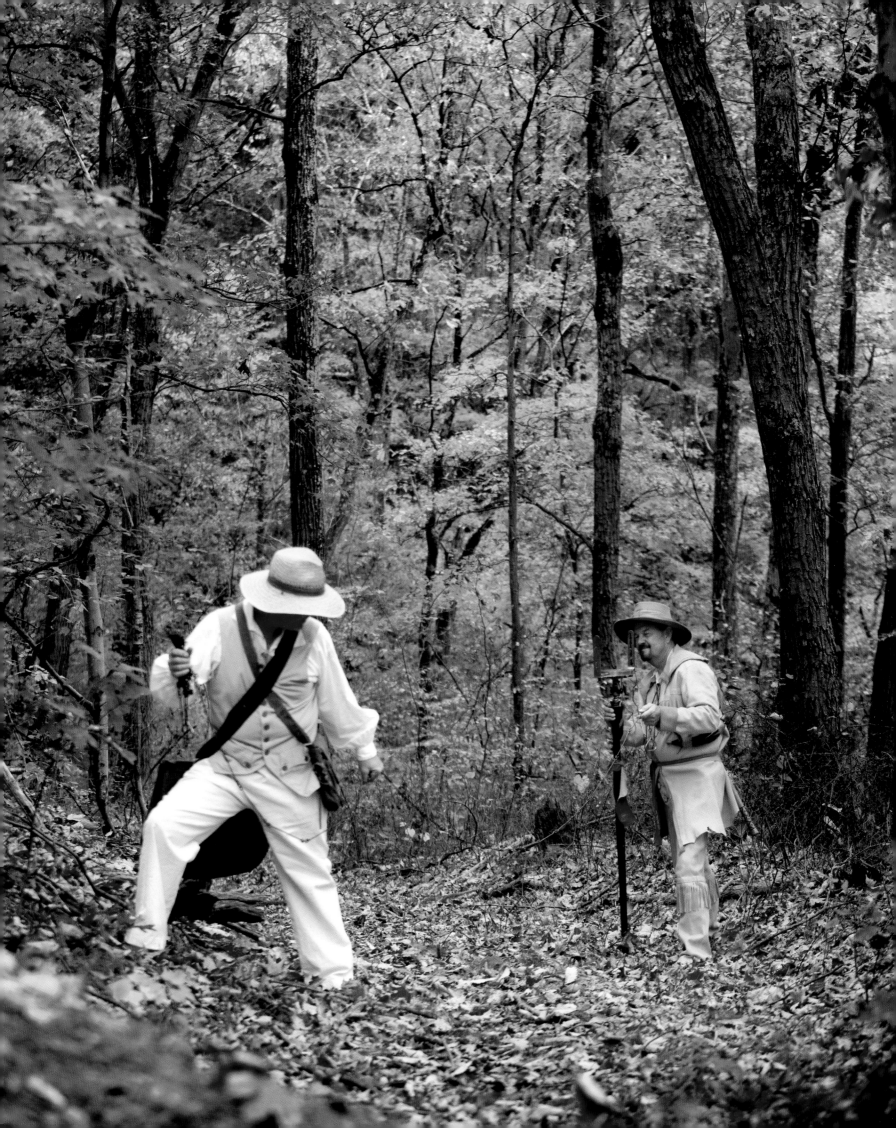

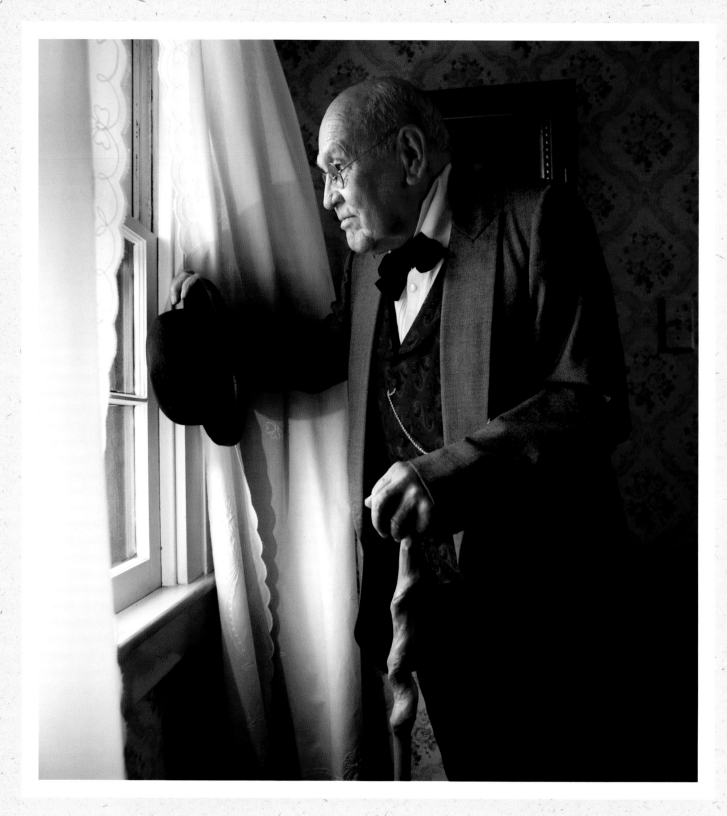

Nineteenth-century New Albany resident "Obadiah Childs" as portrayed by his descendant, David Elliot, at the historic Scribner House

Right: Bicentennial Living History Committee members portray young piano student, "Mary Helen Scribner," and her music teacher at the Scribner House.

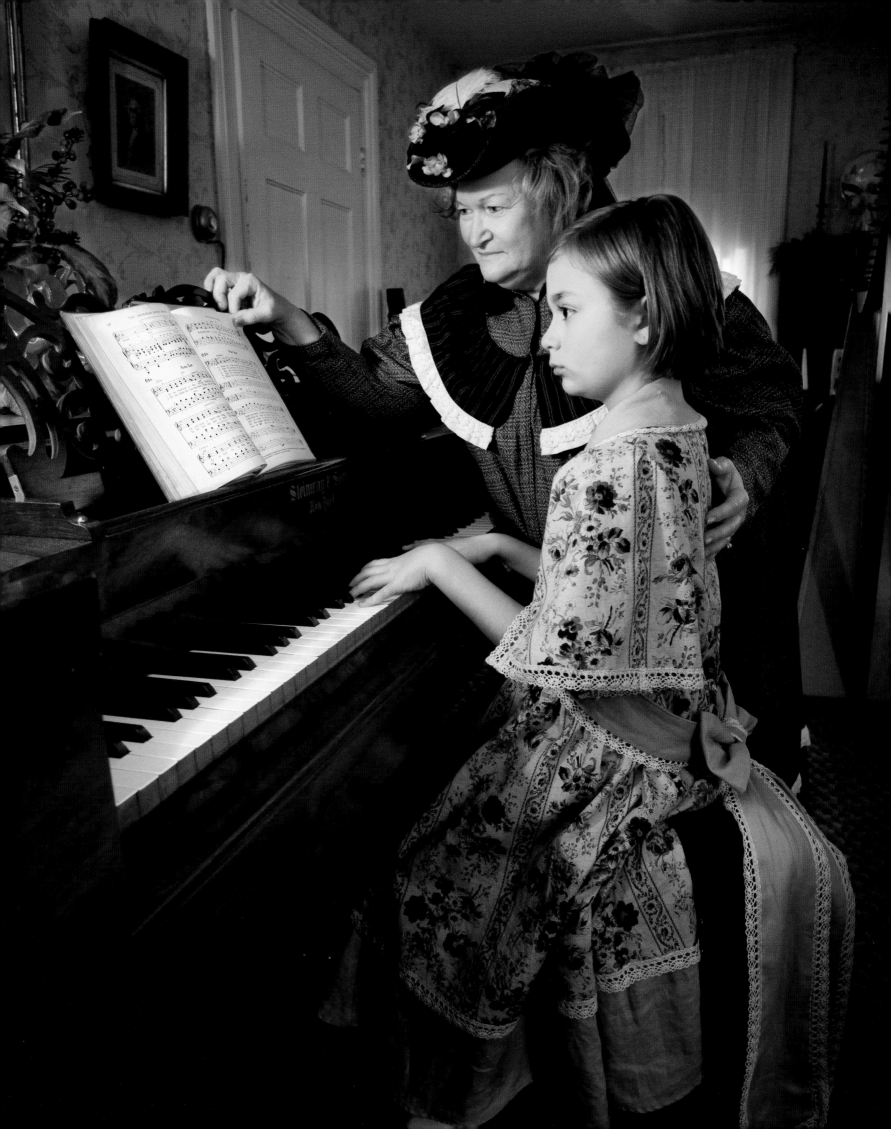

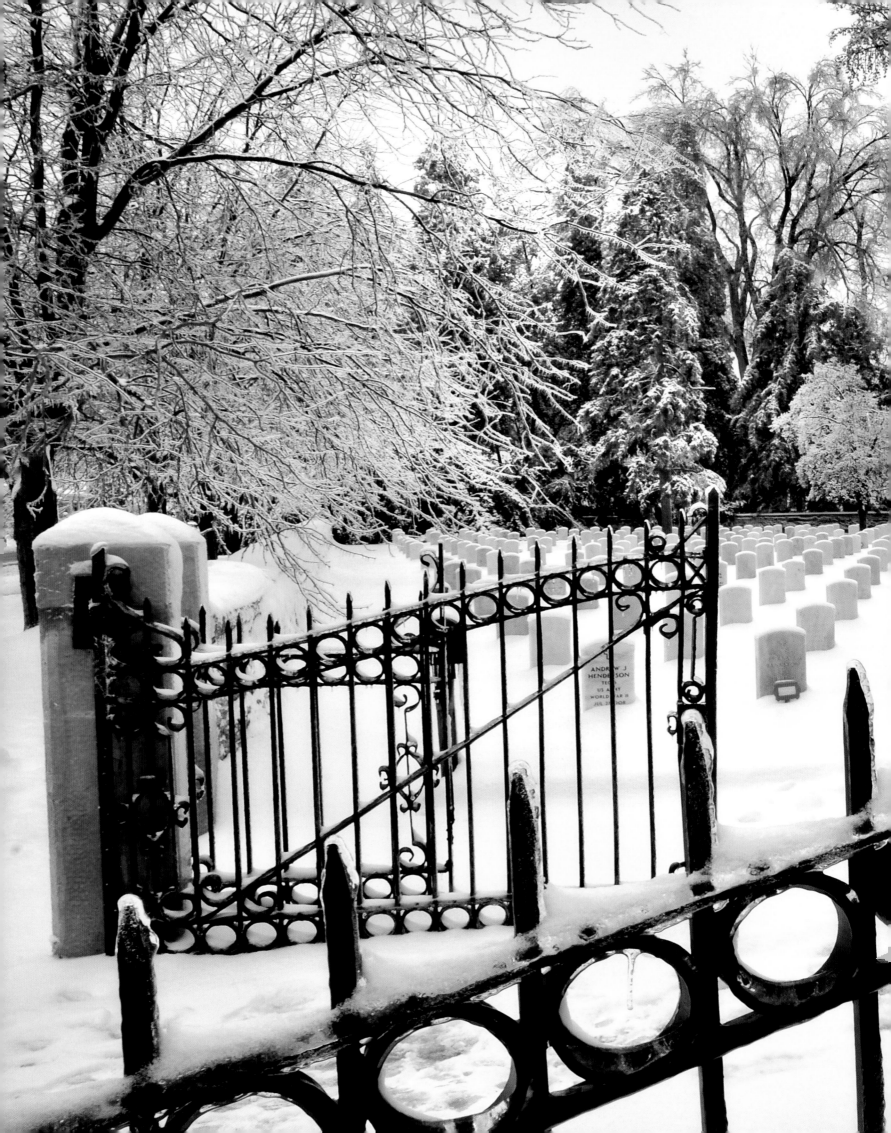

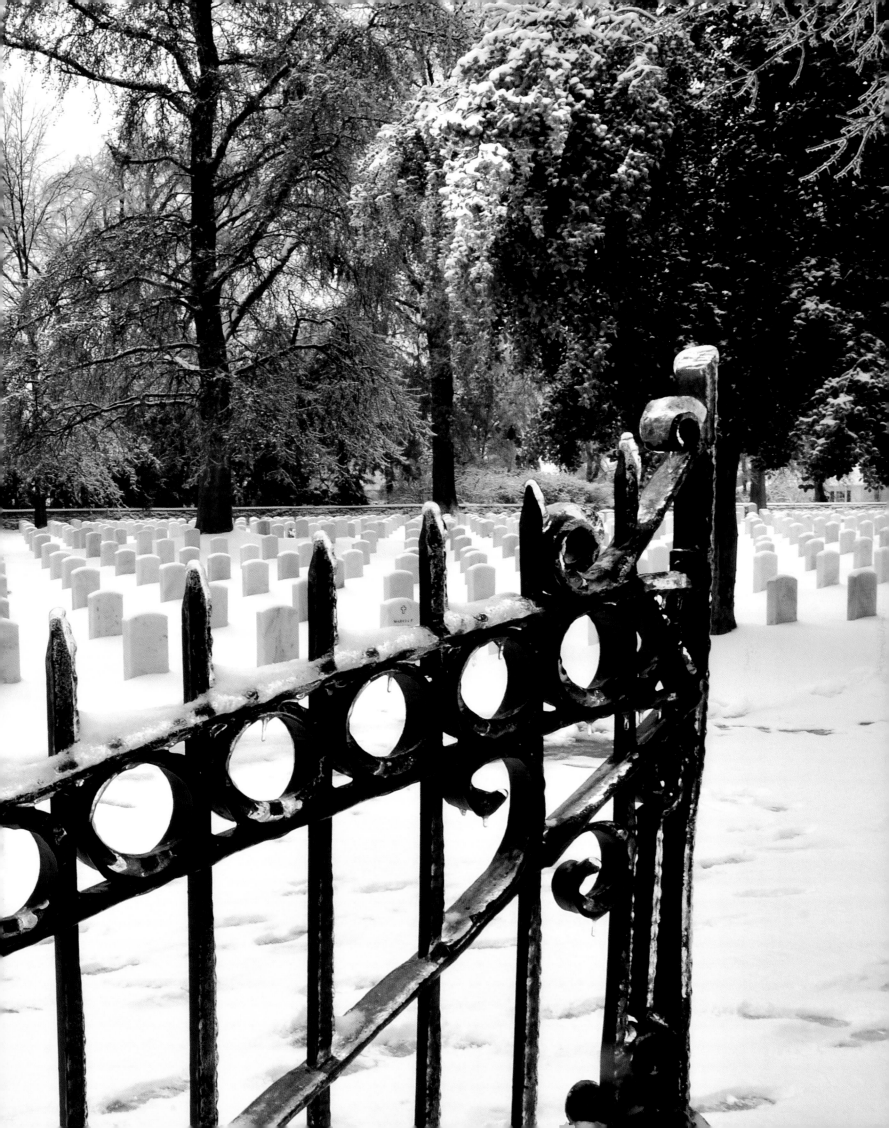

132

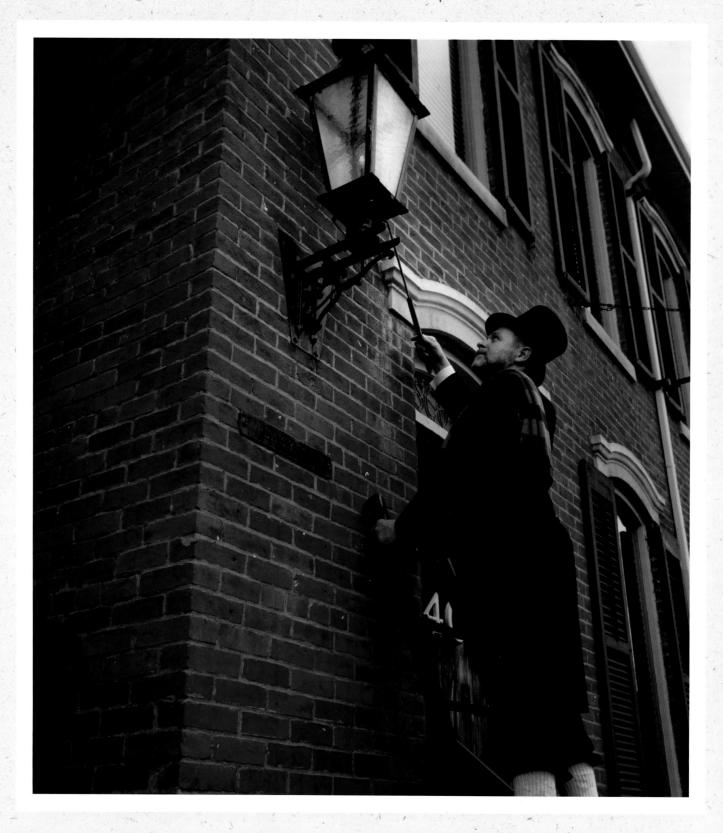

"CHARLES DICKENS ERA LAMPLIGHTER" PORTRAYED BY A BICENTENNIAL LIVING HISTORY COMMITTEE MEMBER.

PREVIOUS SPREAD: WINTER SNOW BLANKETS THE NEW ALBANY NATIONAL CEMETERY
RIGHT: 300 BLOCK OF PEARL STREET DURING THE CHRISTMAS HOLIDAYS

Christmas hand bell concert at Culbertson Mansion State Historic Site

Right: River City Winery at Christmas, 321 Pearl Street

GLENWOOD PARK RESIDENCE IN WINTER SNOW

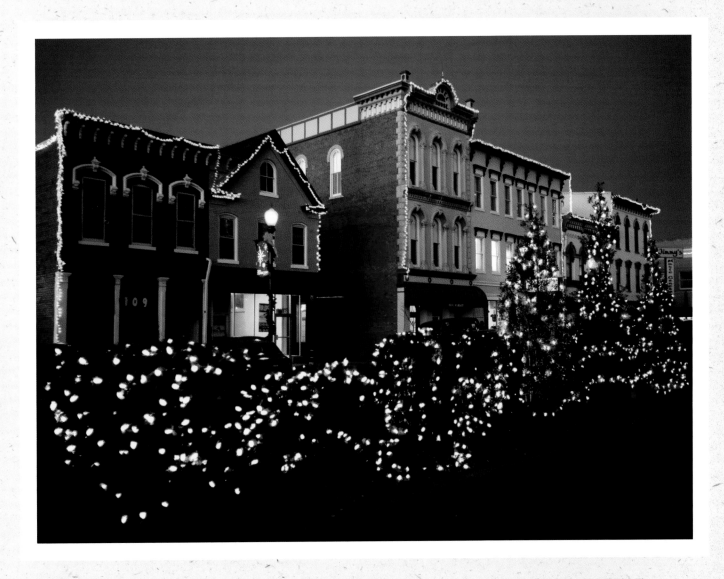

Historic East Market Street structures - Globe Store (1875); Martin Kiefer Saloon (1870); Reibel House (1887); Phillip Kemp Building (1861); Ben Briggs Building (1891); and the John Briggs Block (1872) at Christmas

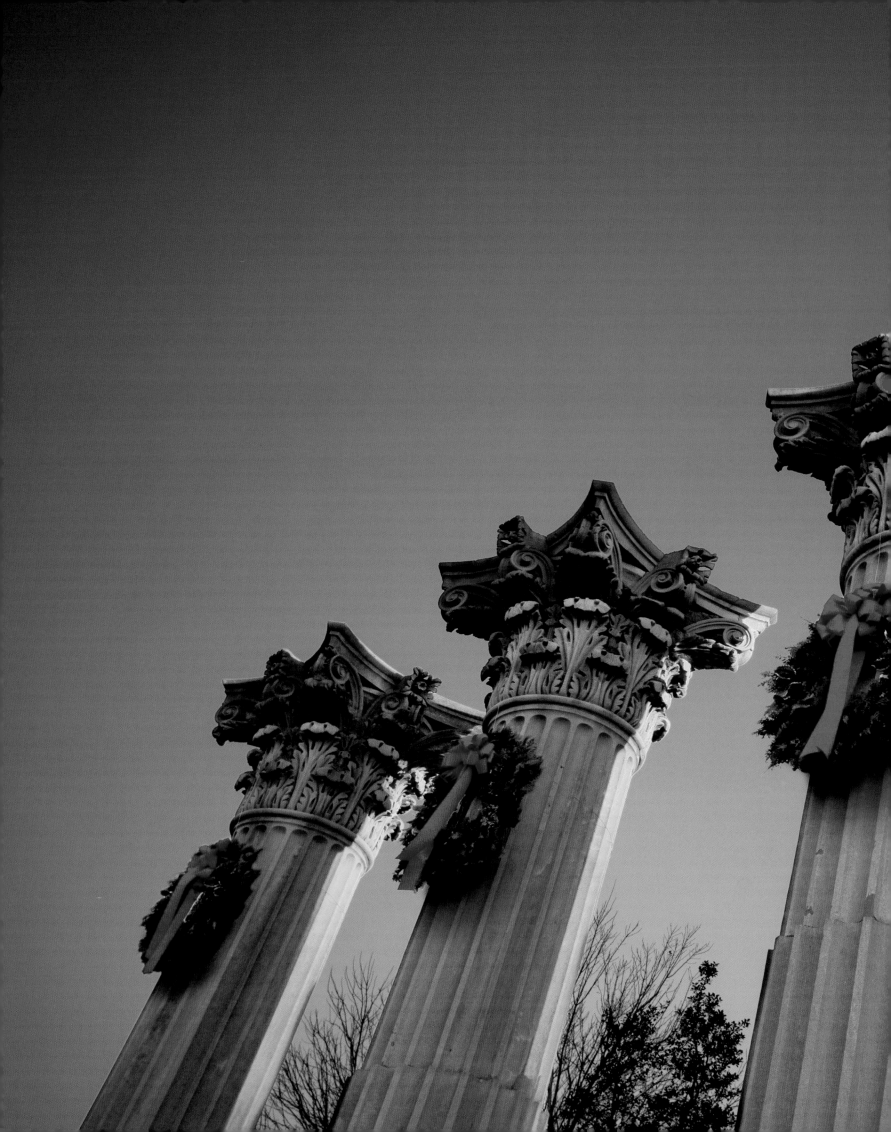

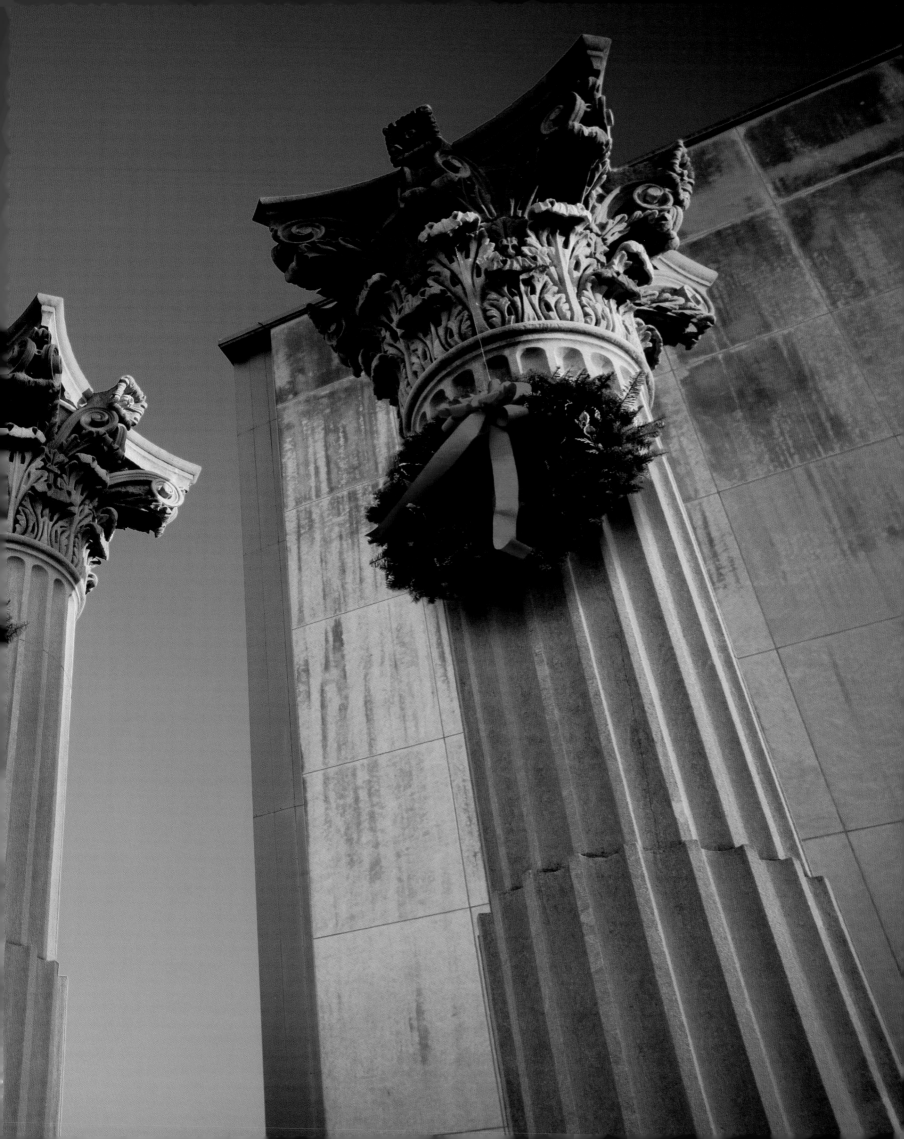

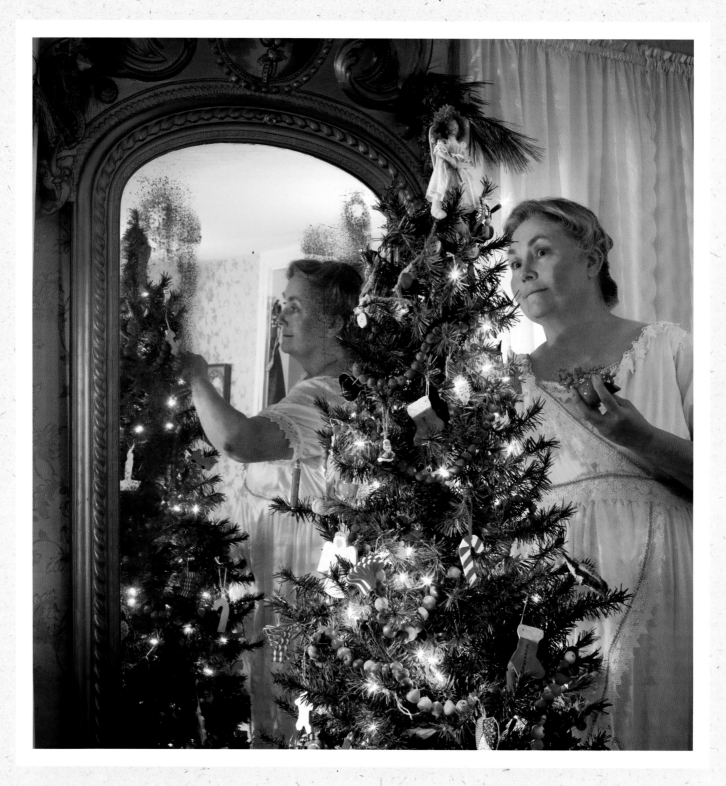

"HATTIE SCRIBNER" DECORATING THE SCRIBNER HOUSE CHRISTMAS TREE AS PORTRAYED BY A BICENTENNIAL LIVING HISTORY COMMITTEE MEMBER

PREVIOUS SPREAD: COLUMNS FROM THE HISTORIC FLOYD COUNTY COURTHOUSE AT CHRISTMAS, SOUTHWEST CORNER OF HAUSS SQUARE AND WEST SPRING STREET
RIGHT: HISTORIC SCRIBNER HOUSE DECORATED FOR CHRISTMAS. THE SCRIBNER HOUSE, BUILT IN 1814 BY NEW ALBANY FOUNDER JOEL SCRIBNER, IS NEW ALBANY'S OLDEST HOUSE, AND IS LISTED IN THE NATIONAL REGISTER OF HISTORIC PLACES.

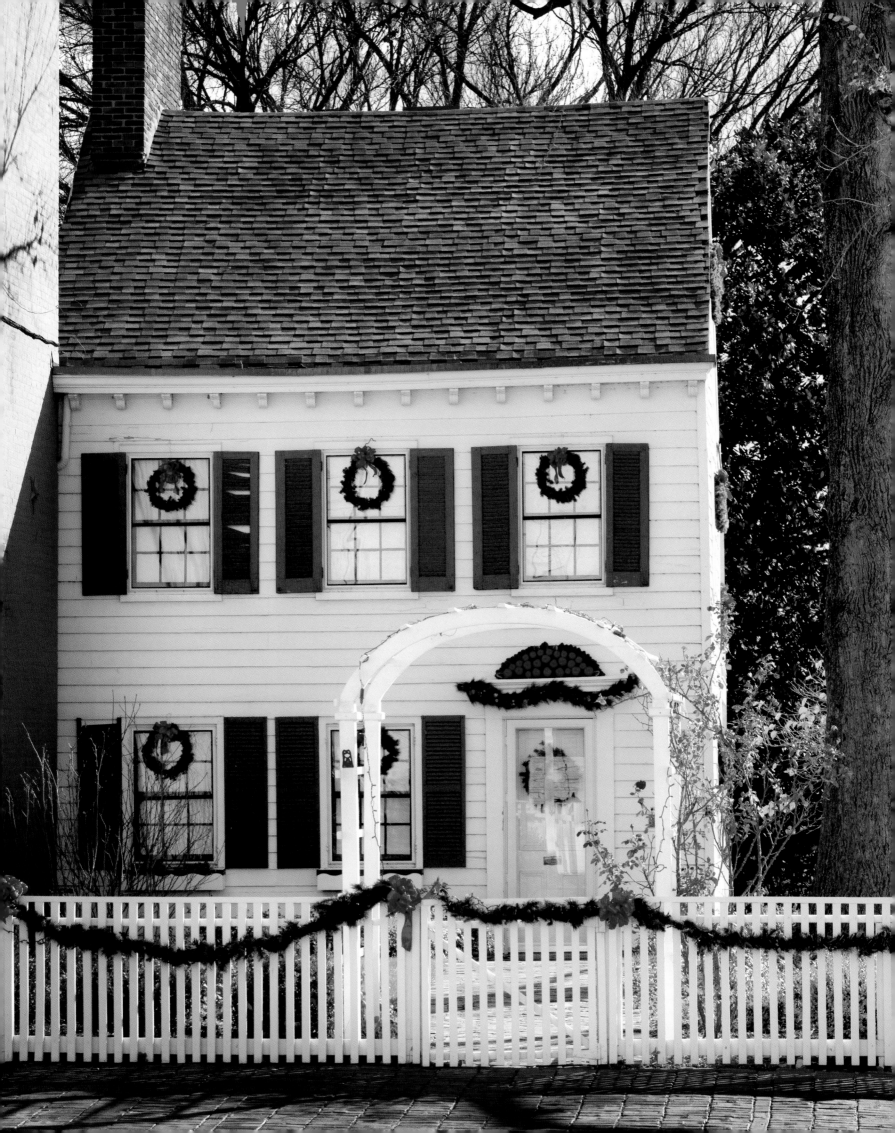

CHRISTMAS MANTEL DECORATION AT CULBERTSON MANSION STATE HISTORIC SITE

RIGHT: CULBERTSON MANSION CHRISTMAS TREE
FOLLOWING PAGE: NEW ALBANY'S CHRISTMAS TREE, NORTHEAST CORNER OF MARKET AND STATE STREETS

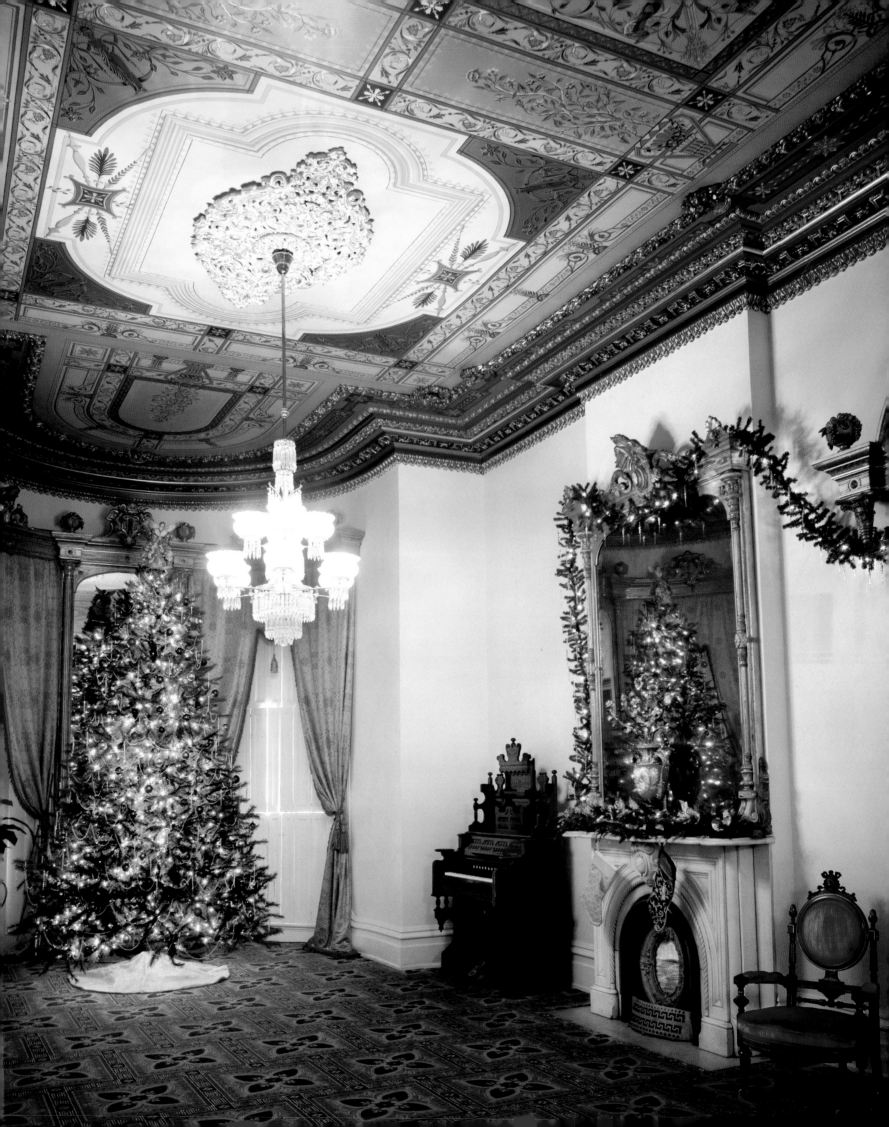